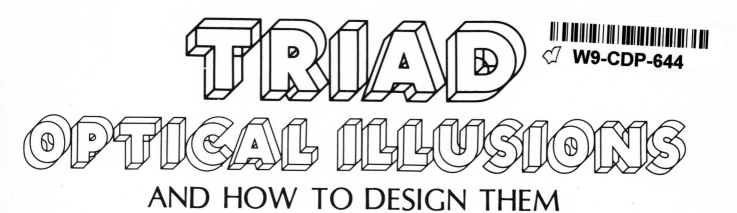

TRIAD
OPTICAL ILLUSIONS
AND HOW TO DESIGN THEM

W9-CDP-644

Original designs and text by
HARRY TURNER

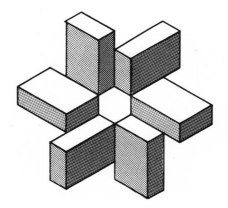

DOVER PUBLICATIONS, INC.
NEW YORK

To Lisa Conesa, who first asked for an explanation; to Howard Lyons and Martin Gardner, who spread the word; and to Hayward Cirker, who brought me a wider audience.

Copyright © 1978 by Harry Turner.
All rights reserved under Pan American and International Copyright Conventions.

Published in Canada by General Publishing Company, Ltd., 30 Lesmill Road, Don Mills, Toronto, Ontario.
Published in the United Kingdom by Constable and Company, Ltd., 10 Orange Street, London WC2H 7EG.

Triad Optical Illusions and How to Design Them is a new work, first published by Dover Publications, Inc., in 1978.

DOVER *Pictorial Archive* SERIES

This book belongs to the Dover Pictorial Archive Series. You may use the designs and illustrations for graphics and crafts applications, free and without special permission, provided that you include no more than four in the same publication or project. (For permission for additional use, please write to Dover Publications, Inc., 31 East 2nd Street, Mineola, N.Y. 11501.)
However, republication or reproduction of any illustration by any other graphic service whether it be in a book or in any other design resource is strictly prohibited.

International Standard Book Number: 0-486-23549-1
Library of Congress Catalog Card Number: 77-81212

Manufactured in the United States of America
Dover Publications, Inc.
31 East 2nd Street, Mineola, N.Y. 11501

By way of explanation

First question. What's a triad?
Suppose you sketch three rectangular blocks—like this:

Imagine one laid out flat,
one left standing upright, and the
third positioned to link them, so:

Then we bring them together . . .

closer . . .

and finish up with this arrangement:

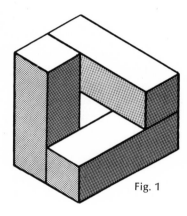

Fig. 1

This drawing of an apparently solid object—three
rectangular blocks linked together by edges touching or
overlapping—is a triad.
You may have noticed something odd about the arrangement.
It's easy enough to draw, and has a convincing solidity,
but if you tried to assemble actual blocks this way it
just wouldn't work out. The triad is an impossible
object, an irrational creation of the imagination that
exists happily in the flat two-dimensional world of a
drawing, but defies realization in three dimensions.
A thoughtful look will show you why, logically, an object
like the triad can't be made in the round.
Second question. So what use is a triad?
Well, the answer to that would fill a book. *Has* filled a
book . . . this one!
The triad shape is a surprisingly versatile design module,
providing the basis for countless impossible or visually
ambiguous figures and structures, besides being an
effective pattern generator. The designs for you to
employ in the center pages of this book are all derived
from variations of the triad unit drawn above. You might
be curious to know how some of the designs were created.
The explanatory notes following, based on material from
my sketchbooks, show some of the ways a basic triad shape
is transformed into radically different shapes, is linked
effectively into larger structures, is manipulated to
produce decorative graphics, or is extended as fascinating
all-over patterns that seem to exist beyond the plane of
the drawing-paper surface.

 Harry Turner

1

Point of view

The triad is a figure drawn in isometric perspective. Sir William Farish invented this system of technical drawing during the industrial revolution in eighteenth-century Britain, though it might be asserted, on the evidence of one of his drawings, that Leonardo da Vinci anticipated the invention, as he did so many others! Isometric projection is a drawing method based on the use of true dimensions, in which an object is viewed so that all sides appear equally foreshortened (2). The draftsman measures length, width and thickness on three axes, one vertical and the other two drawn 120° apart. The end result shows all dimensions correctly while being more pictorial and immediately informative than the conventional three-plane projection drawing of the engineer, with its three separate views of an object.

Fig. 2

Alas, Sir William's invention was not too successful—the complexities of drawing with the system can be time-consuming, and the detail sometimes confusing. It's interesting to note that artists, faced with the problem of siting objects in pictorial space, have often used forms of this oblique perspective. Indeed, there are prints made by Japanese artists contemporary with Sir William, which show the use of angular isometric perspective in the backgrounds. But our interest in the system is that it creates a special kind of pictorial space, an illusory universe in which odd things happen.

Drawing a triad

As a drawing aid, we can construct an isometric grid by superimposing equal-spaced lines at 120° intervals (3). Then we forget its original purpose—translating solid objects into a flat space. We exploit the grid by suggesting that the two-dimensional shapes drawn on it represent three-dimensional objects. In this way, we use the system perversely to create a paradoxical space, a confusing world in which there is no fixed viewpoint, no focused perspective, in which objects are apparently seen from two viewpoints—we look down on them or up

Fig. 3

at them, and occasionally experience both viewpoints simultaneously.

Constructing a triad in this space is easy. First, sketch a triangle of equal sides and extend each side by a line of equal length. Complete a parallelogram on each side, then extend the drawing by adding a unit thickness to each of the shapes. The result is a drawing of a solid object in isometric perspective. Adding tone or color to this outline heightens the effect of solidity (4).

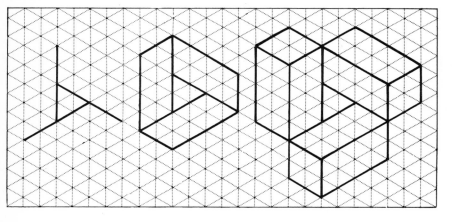

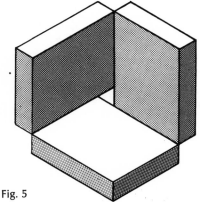

Fig. 4

Now we can try some variations on this shape. Keeping the "thickness" constant, draw a series of triads with inside dimensions of the blocks increasing systematically: the shapes sketched on the grid show the changing dimensions. The end result is a box-shaped triad (5)!

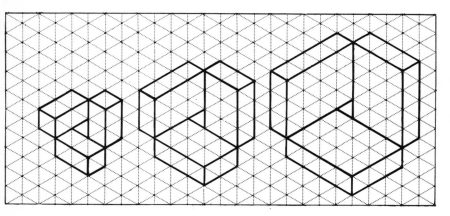

Fig. 5

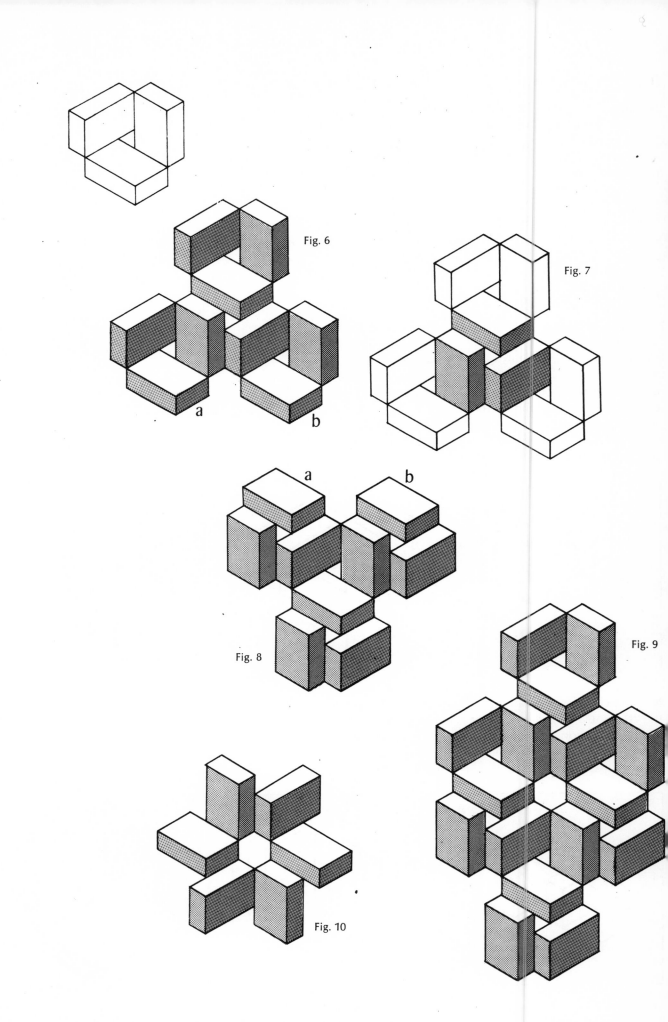

Fig. 6

a

b

Fig. 7

a

b

Fig. 8

Fig. 9

Fig. 10

Linking box triads

Link three of these box-shaped triads, as shown in Figure
6. Look at the center of this shape—hidden there is a
different box, which looks as if the first shape has been
rotated and viewed from behind (7).
Linking three of these new triads provides us with another
viewpoint of the original linked figure (8). If we now link
Figures 6 and 8, overlapping the blocks marked a and b,
the resulting drawing suggests a modern sculptural
project (9). In the center is a hexagon around which
blocks are grouped whirligig-fashion. Oddly, this is not
an impossible shape (10), but becomes one immediately when
blocks are added to complete the triads.
Figure 9 may be extended in any direction simply by adding
identical box triads to complete the hexagon shapes. The
resultant all-over pattern is reminiscent of Islamic
geometrically based designs.

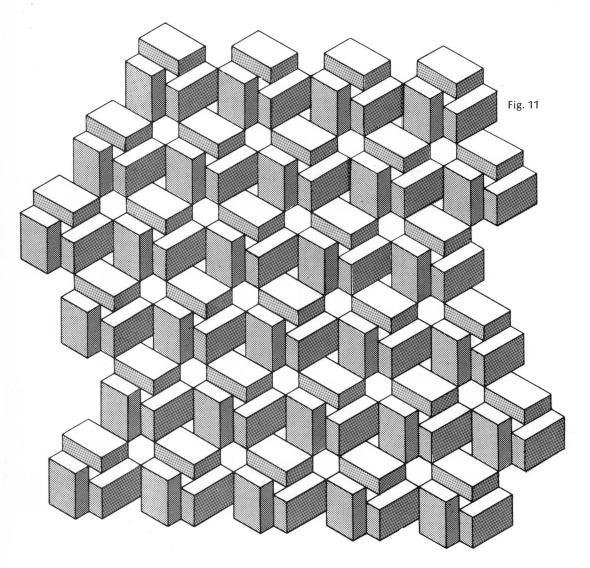

Fig. 11

Most of the triads are useful modules for generating
these periodic patterns, often revealing unsuspected
intricacies as the design expands.

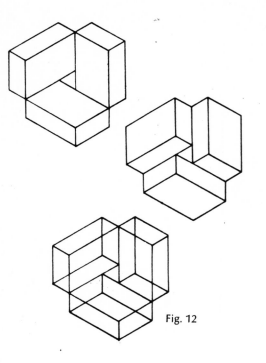

Fig. 12

Ambiguous shapes and illusions

Look again at the box triad we've been manipulating. Both figures are contained within the same contour: imagine it to be a wire structure, or an assembly of blocks of clear plastic (12). It is difficult to interpret the shape because of this dual spatial relationship. When we try to resolve the ambiguous image its orientation in depth fluctuates spontaneously . . .

This distracting alternation of attention within an image is the basis of many geometrical optical illusions—typical examples are shown below.

In Mach's reversible open-book figure (13) are we looking at the covers or the inside pages? It can be interpreted as an object seen from above or below.

Similarly, it is difficult to decide if Thiery's figure (14) exists above or below eye level. At times it appears to do both simultaneously.

How many cubes are there in the next shape—one, two or three? It tends to change as we look, and we see what we expect to see (15).

Fig. 13

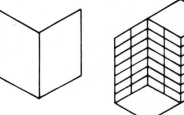

Fig. 15

Fig. 14

Fig. 16

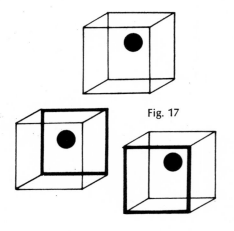

Fig. 17

Schröder's steps (16) are apt to invert in a disquieting way as we stare at them.

When you look at the Necker line projection of a cube (17), do you see it from above or below, and is the black disk on the front or rear face, or inside the cube?

These figures are confusing because they are patterns containing no definite clues as to which aspect is perceptually "correct." How do you read the shapes in Figure 18—as a series of flat ellipses or as views of a rotating disk?

We tend to interpret these diagrams as representations of objects because the shapes create a certain sense of movement above and below the paper surface. It often

Fig. 18

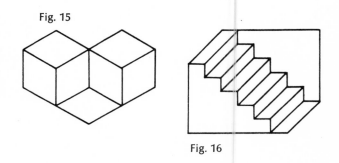

requires a mental effort to accept them for what they are—simple flat geometrical shapes.

We are not always aware of the extent to which lines in two dimensions deceive the eye (and mind). Think how you grasp a whole comic situation from the simple lines of a cartoon. The image that falls on the retina of the eye resembles a cartoon from which we try to interpret the outside reality. Not surprisingly, we make mistakes.

Richard Gregory has described perception as continuous problem solving, because there is never enough information from the eye alone to specify external objects—the brain has to call on memorized sensory data to read a host of non-optical qualities into the images that are triggered by light falling on the retina. Our perception is so dominated by visual stereotypes that, for much of the time, we tend to see what we expect to see.

All these optical illusions exploit this capacity to complete images in the mind's eye on the basis of past experience, by stimulating the imagination to override the simple logic of two-dimensional graphics.

Triads start out by being paradoxical shapes. They become even more improbable when they are combined with one side common to both shapes, as shown in Figures 19 and 20. Note how the common linking blocks in these two sketches are reminiscent of Thiery's figure.

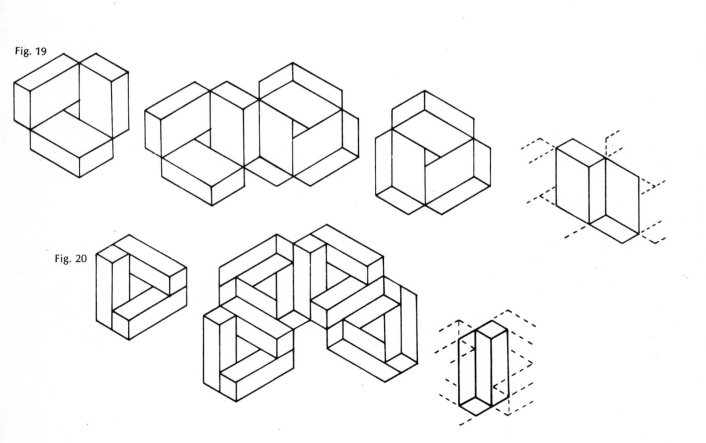

Fig. 19

Fig. 20

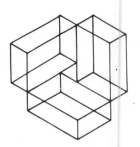

More variations on a theme

So far, triads have been drawn as if they were solid blocks. Here are a few variations derived from our transparent shape. First, the outline may be read as open trays or frames (21). Alternatively, the blocks may be drawn to appear hollow (22).

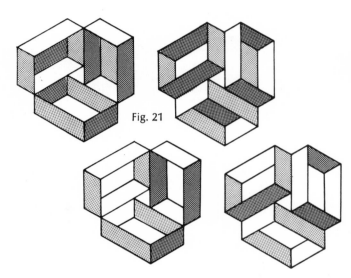

Fig. 21

Fig. 22

The blocks may be split to add a decorative quality to the triad modules built into structures or arranged as pattern (23). From that it is easy to visualize making half of each block triangular (25) or, indeed, just using triangles in place of rectangular blocks (26). And to produce results of increasing complexity, the split blocks can be separated and opened up (24, 27, 28).

Fig. 23

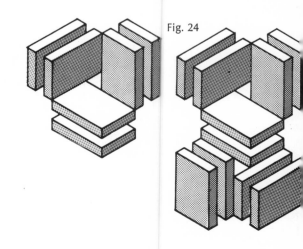

Fig. 24

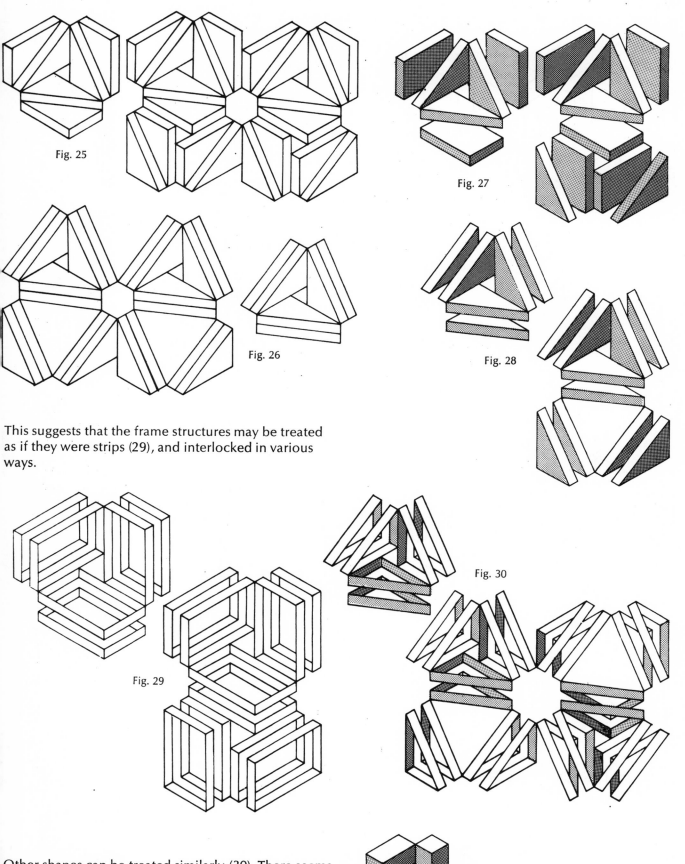

Fig. 25

Fig. 26

Fig. 27

Fig. 28

This suggests that the frame structures may be treated as if they were strips (29), and interlocked in various ways.

Fig. 29

Fig. 30

Other shapes can be treated similarly (30). There seems no end to the possibilities! But before we get involved too deeply, let's return to our beginnings, and try our hand at some simple conjuring tricks . . .

Fig. 31

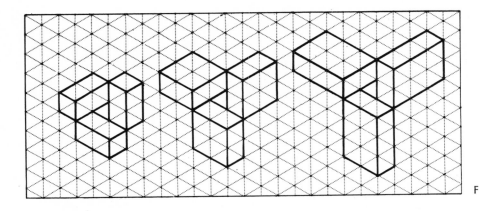

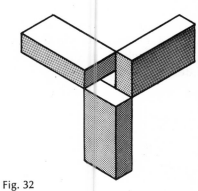

Fig. 32

Some conjuring tricks

There's more that can be done with the triad in Figure 4. Let's vary the dimensions again, this time maintaining the dimensions of the center panels, while regularly extending the outer edges of the blocks. The end result is a little unexpected . . . a "flying" triad, no less (32).

Now, if we combine the shapes in Figures 5 and 32, pivoting them on the triad that has been the starting point in each case, we get the sequence below (33), showing the transformation of a box triad into a flying triad.

Fig. 33

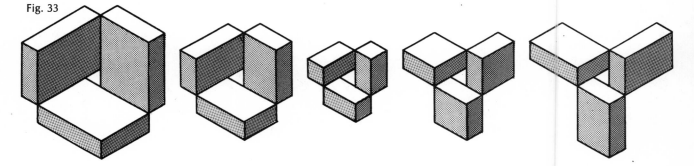

But we're neglecting that first triad, way back on page 1. What happens when we use it as a starting point for a sequence? In Figure 34 the thickness of the blocks is kept constant while the width is extended systematically.

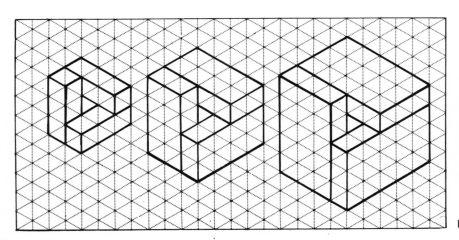

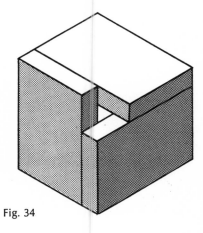

Fig. 34

The end result may seem obvious, but when we repeat the procedure of maintaining center dimensions, while extending the ends of the blocks, we find suddenly that we have come full circle. The "open-box" triad at the start of the sequence has been turned inside out in the final shape!

Fig. 35

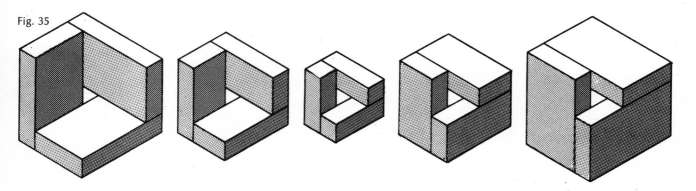

These changes are featured in some of the designs in the center pages. But be warned before you try it out for yourself—conjuring tricks are apt to go wrong. So don't be surprised if something like this happens . . .

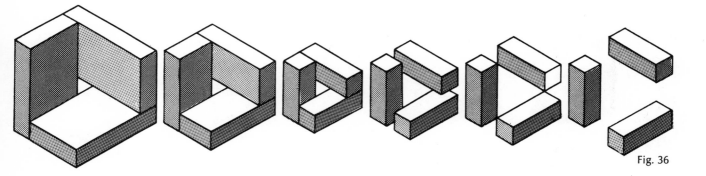

Fig. 36

On page 7 mention was made of triads linked by a common section, a method of linking that introduces a variation of the Thiery illusion into the drawing. Such a Thiery link combines figures with opposing aspects of isometric perspective—we are apparently looking up at one figure and down at the other. It is a useful device to employ when you wish to indulge in pictorial conjuring tricks, and there are many examples on these pages.

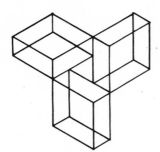

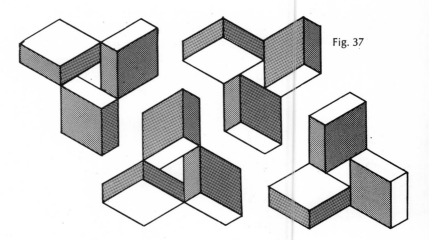

Fig. 37

Flying triads

Linking flying triads around a hexagon produces a structure resembling a space satellite (38). The design is drawn to a larger scale and continued in outline, to indicate how it extends into an all-over pattern (39).

At the heart of the design is a near relation to the whirligig shape seen in Figure 10.

Fig. 38

Fig. 39

Fig. 40

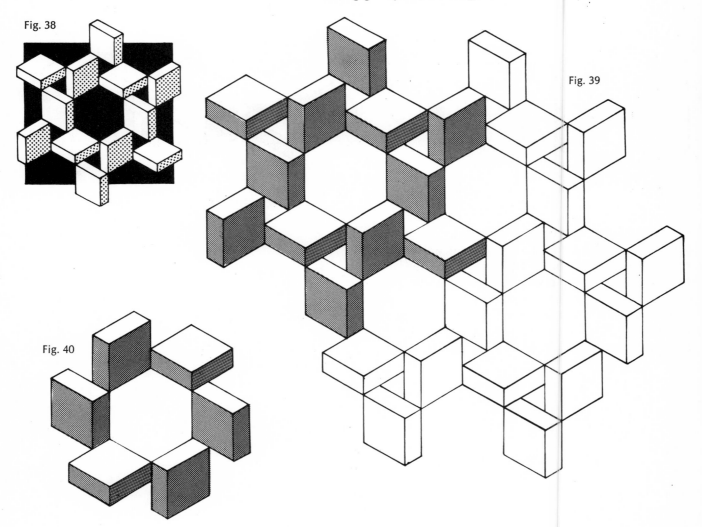

Varying the dimensions of the units forming whirligigs
changes the appearance of the triads and the resultant
design structures when they are linked (41, 42, 43).

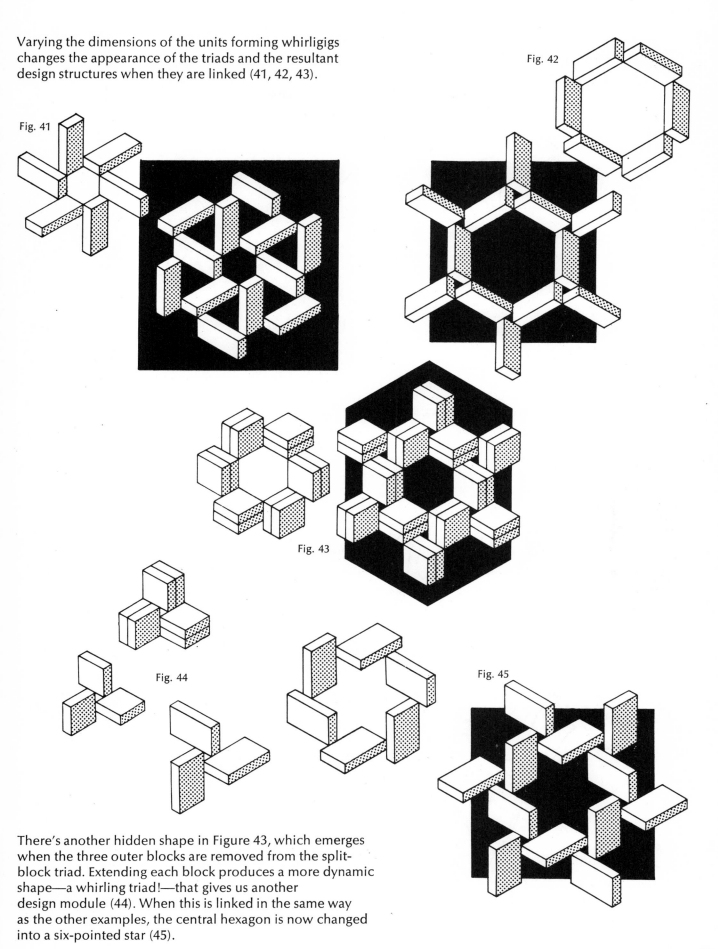

Fig. 41

Fig. 42

Fig. 43

Fig. 44

Fig. 45

There's another hidden shape in Figure 43, which emerges
when the three outer blocks are removed from the split-
block triad. Extending each block produces a more dynamic
shape—a whirling triad!—that gives us another
design module (44). When this is linked in the same way
as the other examples, the central hexagon is now changed
into a six-pointed star (45).

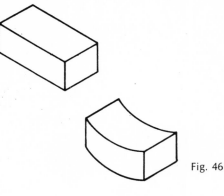

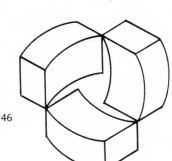

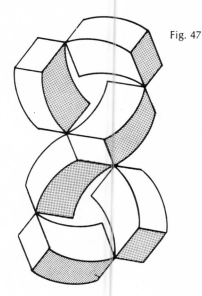

Fig. 47

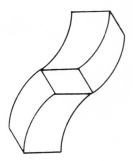

Fig. 46

Flexed triads

New variations open up if the rectangular blocks are flexed. Open-box triads made up of these curved shapes (46) can be joined with a Thiery link to produce an irrational figure-eight structure (47).
The link module itself may be adapted as a design unit. A typical pattern based on it, which may be extended as desired, is shown in Figure 49.

Fig. 48

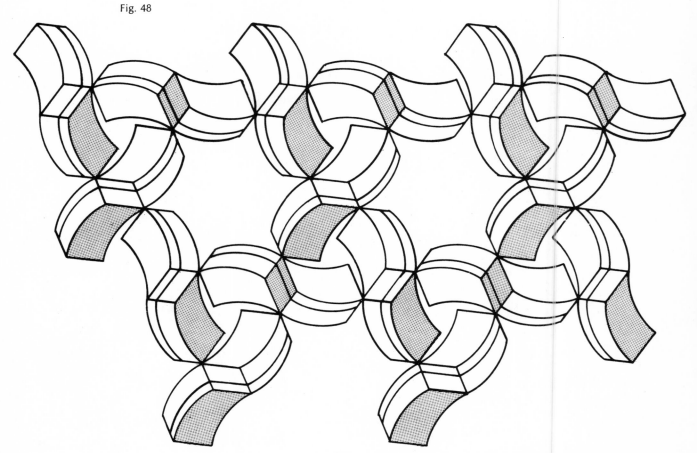

(The text pages continue after the center design section.)

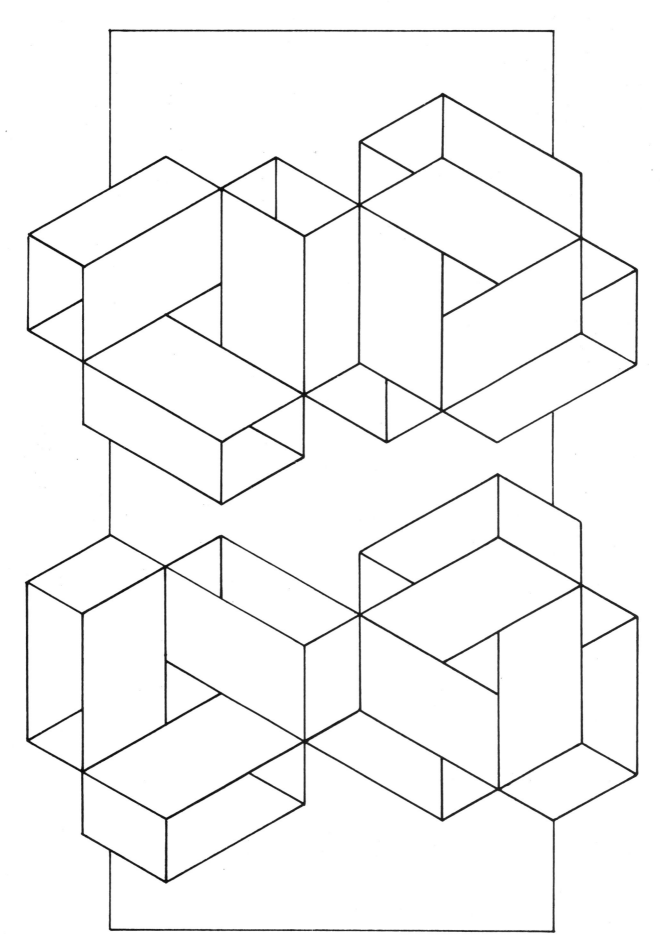

Plate 1

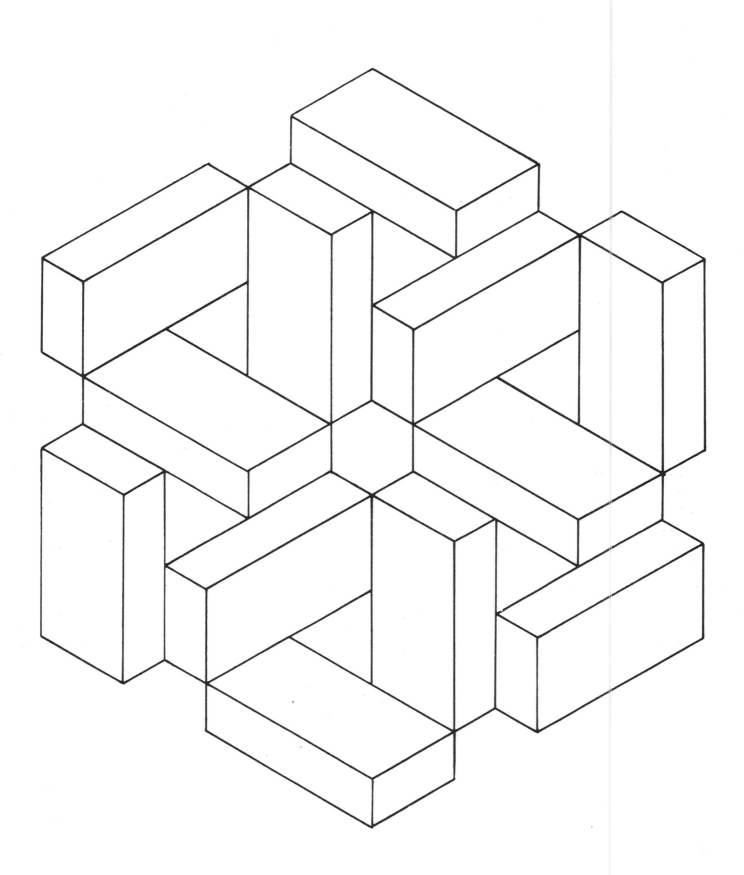

Plate 2

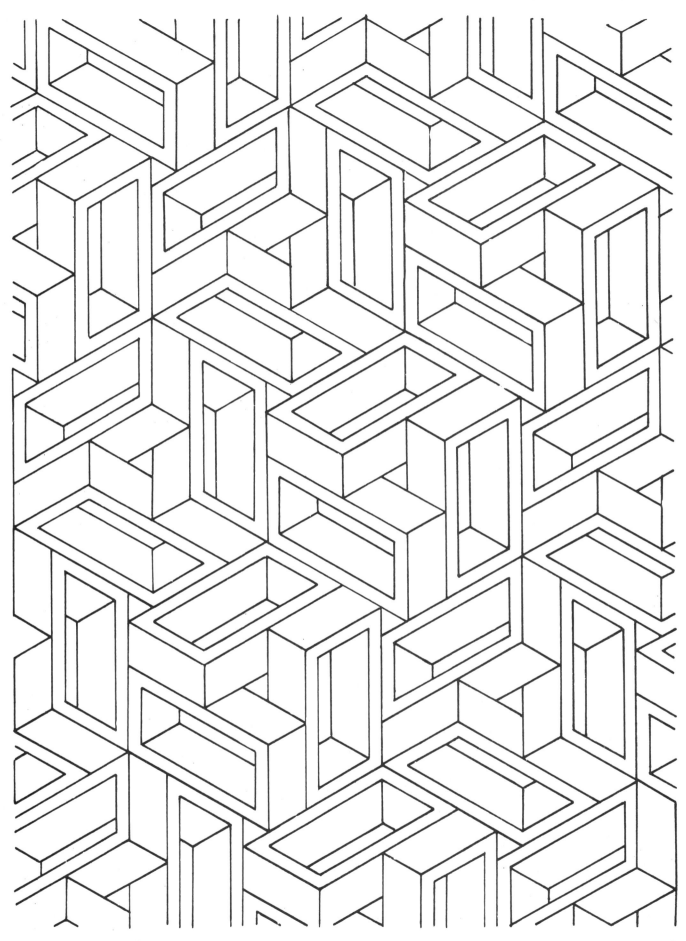

Plate 3

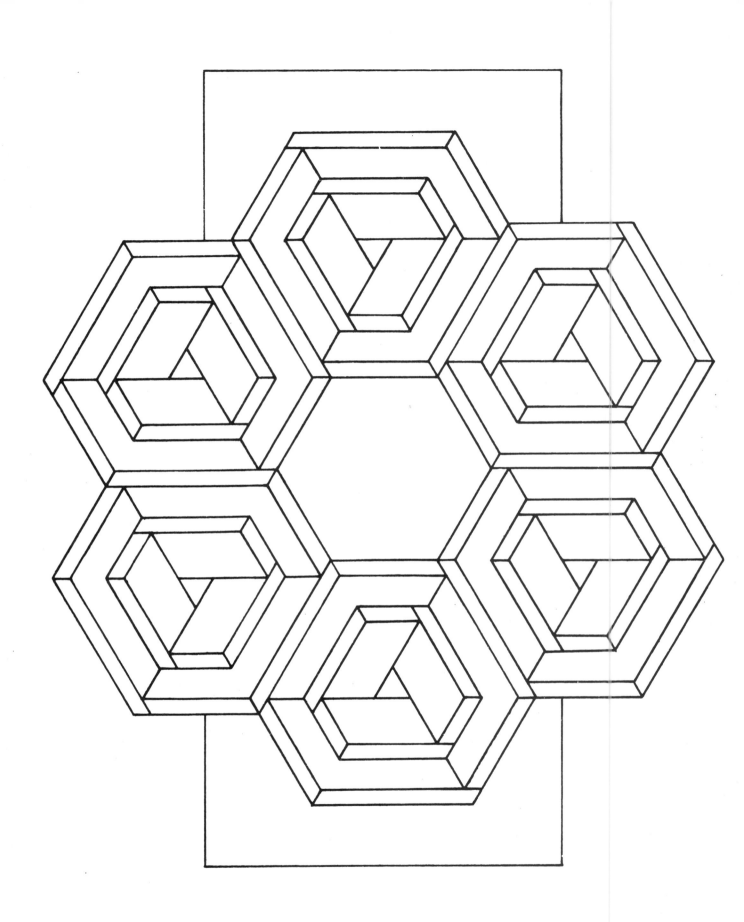

Plate 4

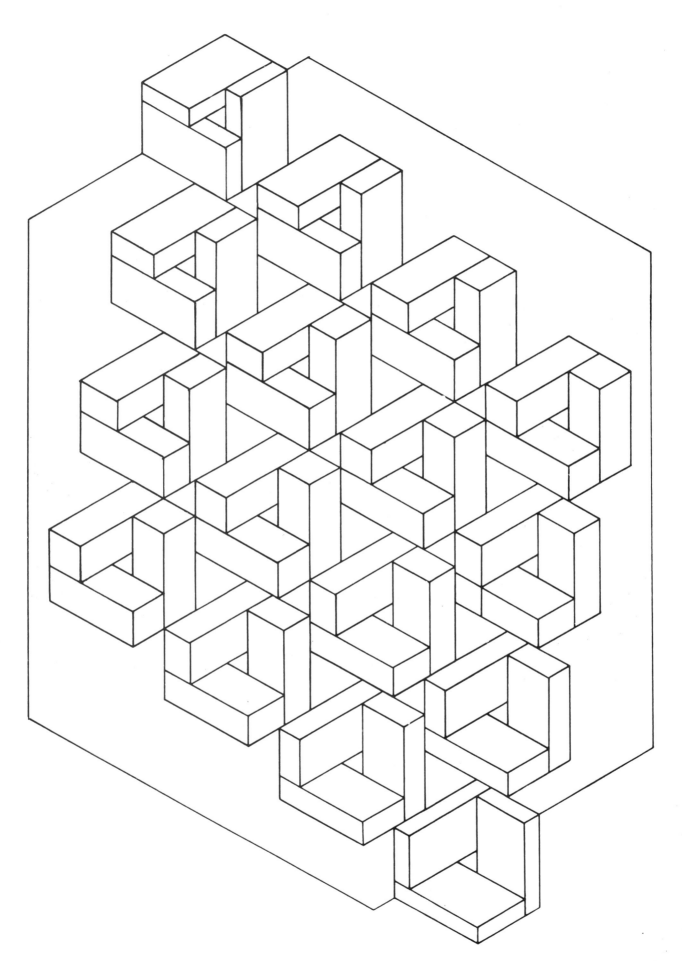

Plate 5

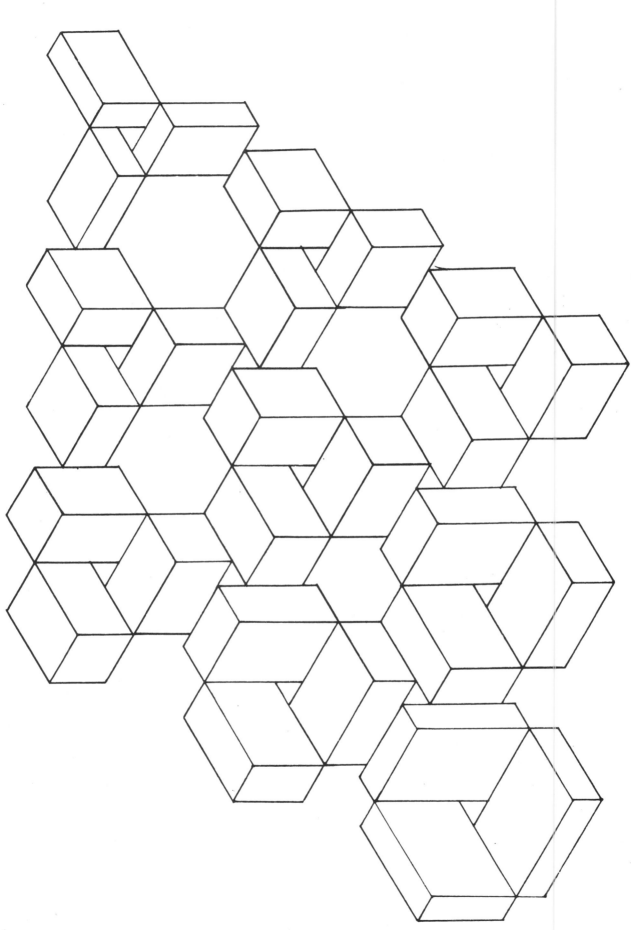

Plate 6

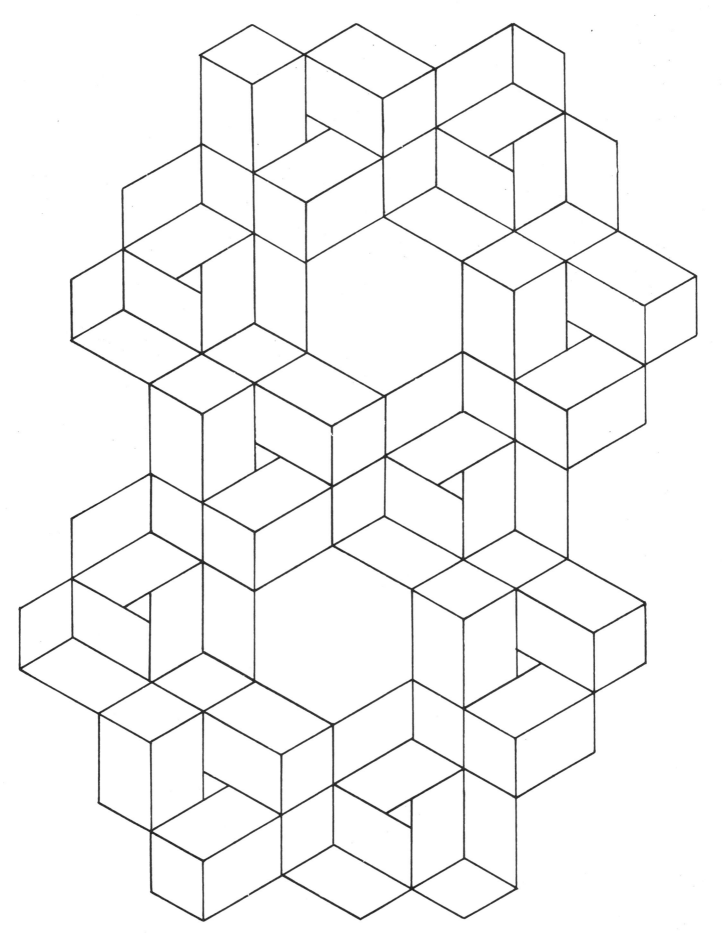

Plate 7

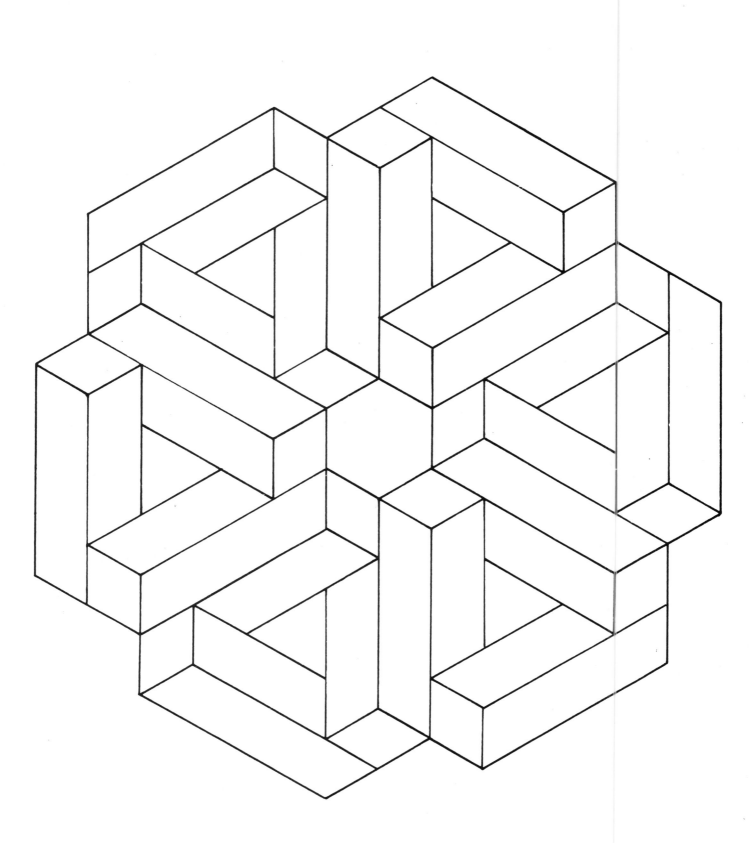

Plate 8

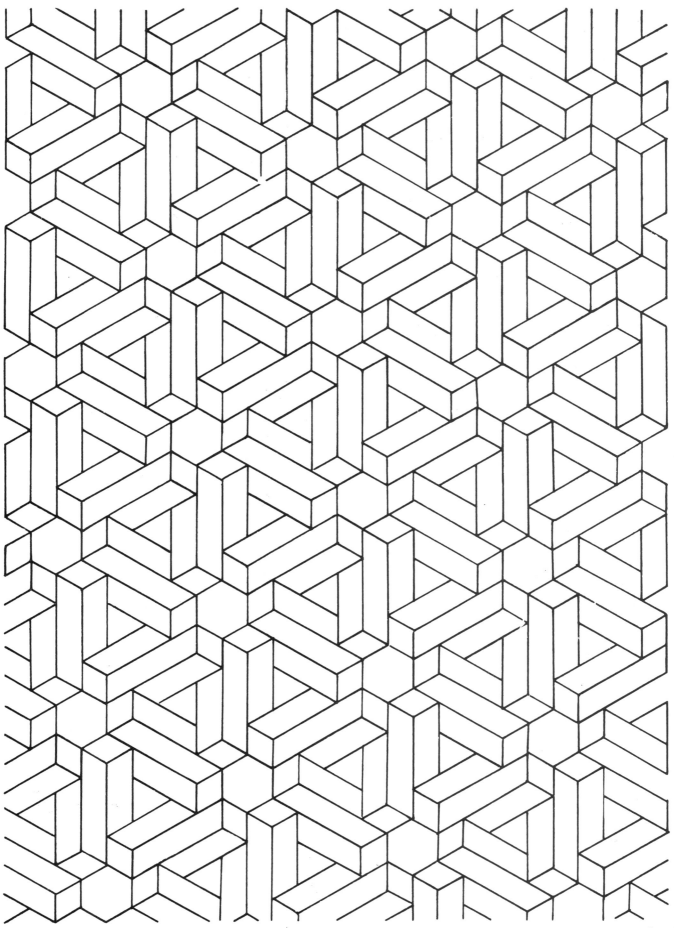

Plate 9

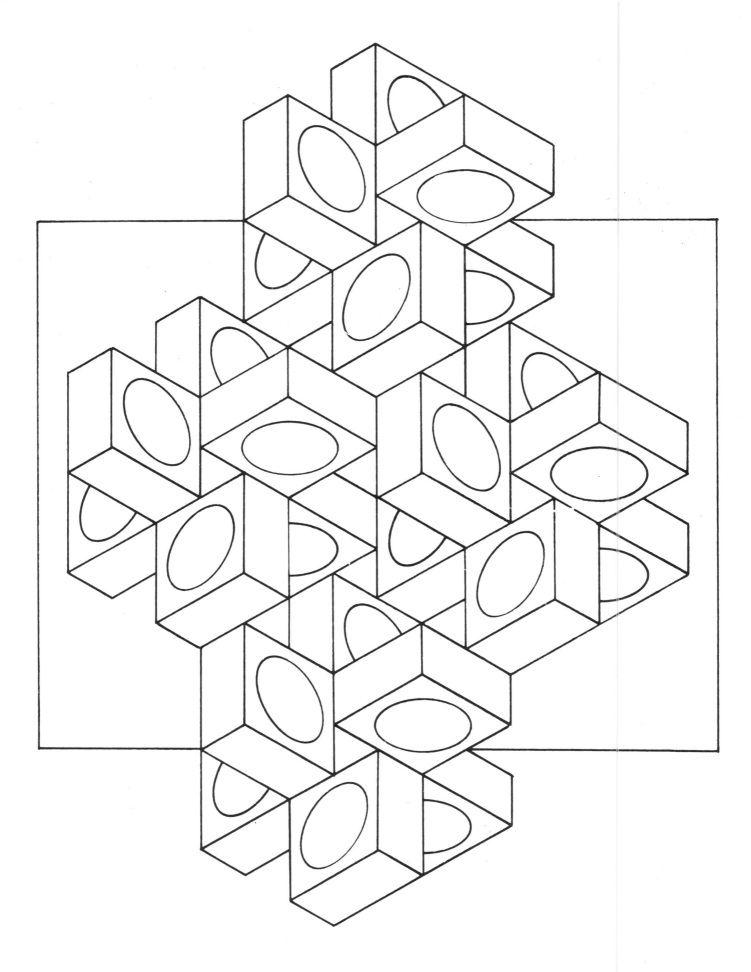

Plate 10

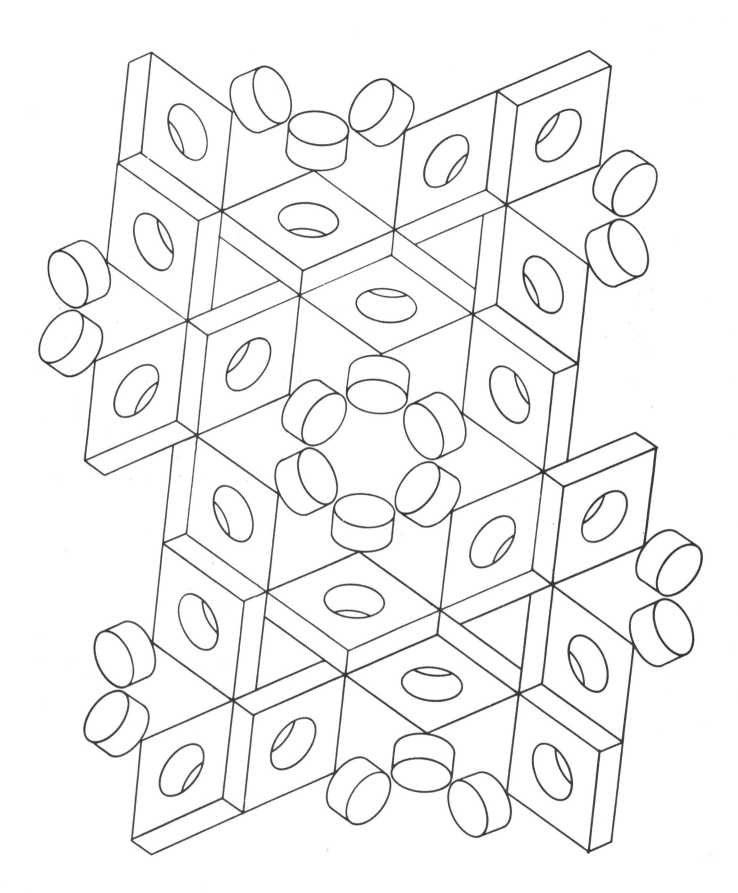

Plate 11

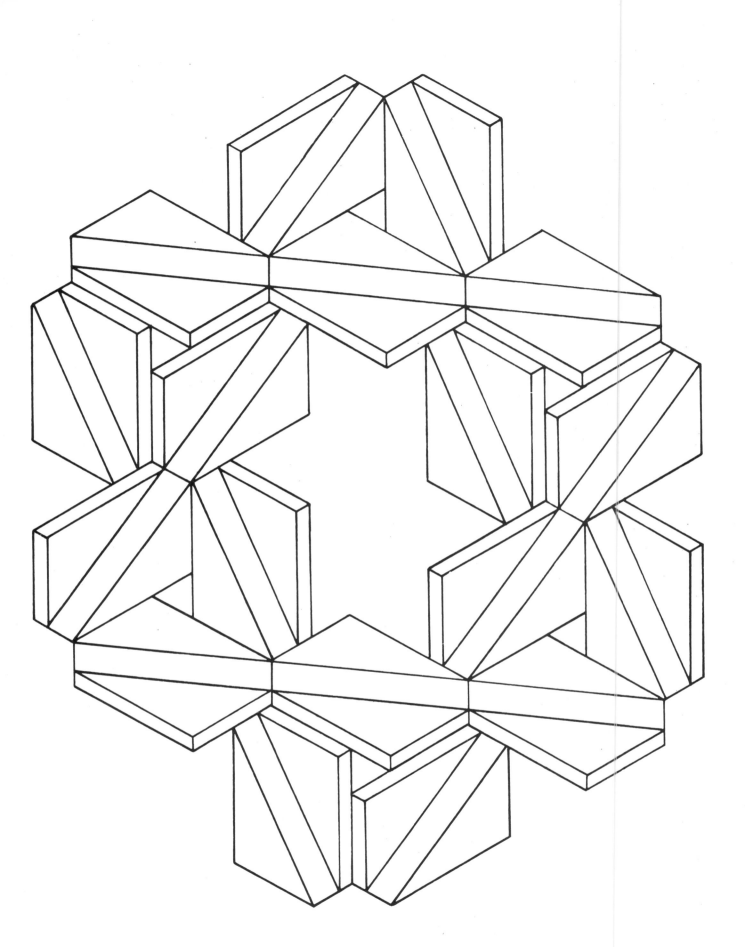

Plate 12

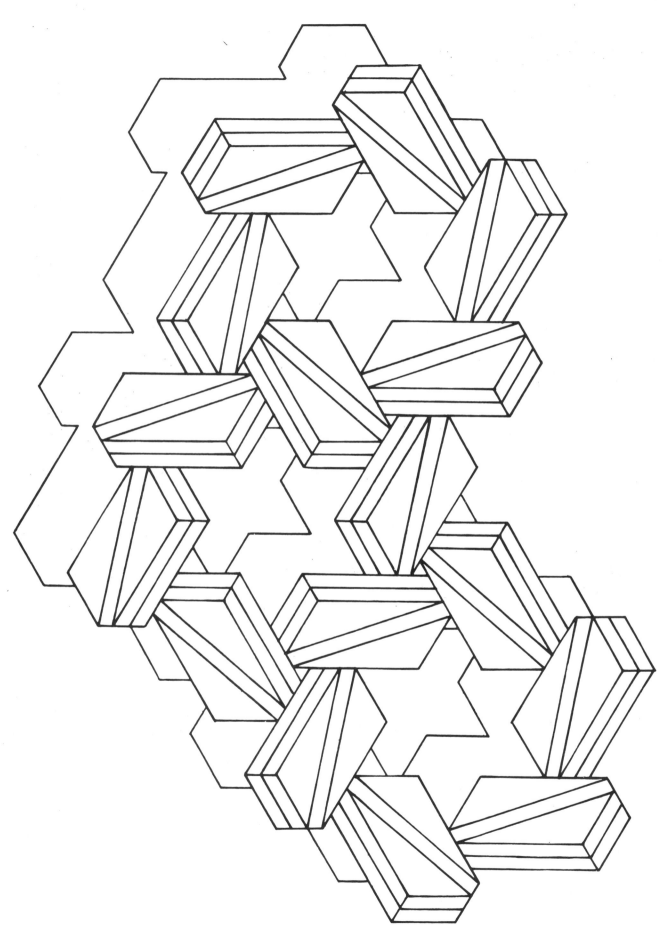

Plate 13

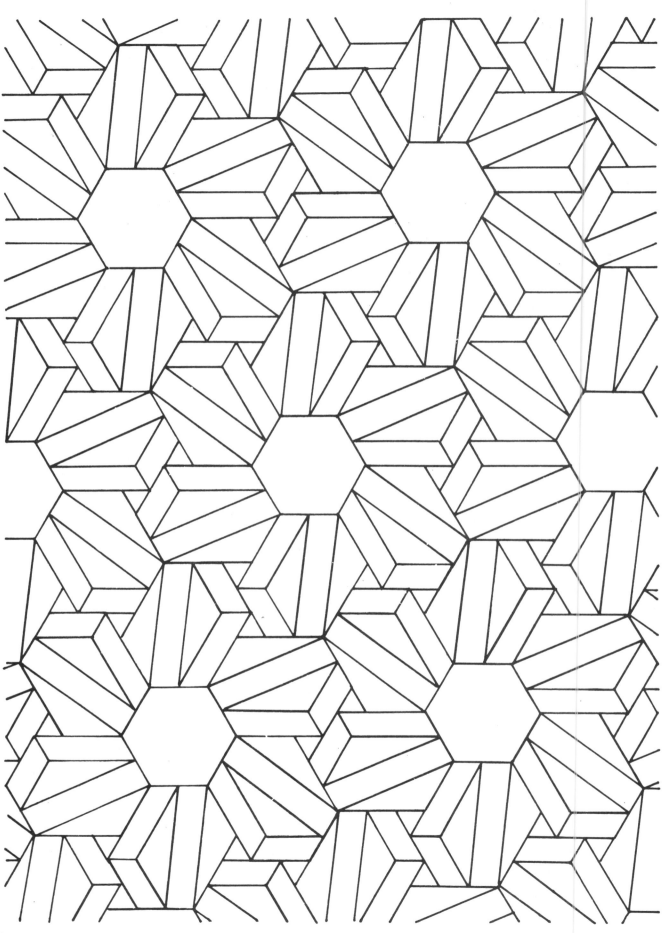

Plate 14

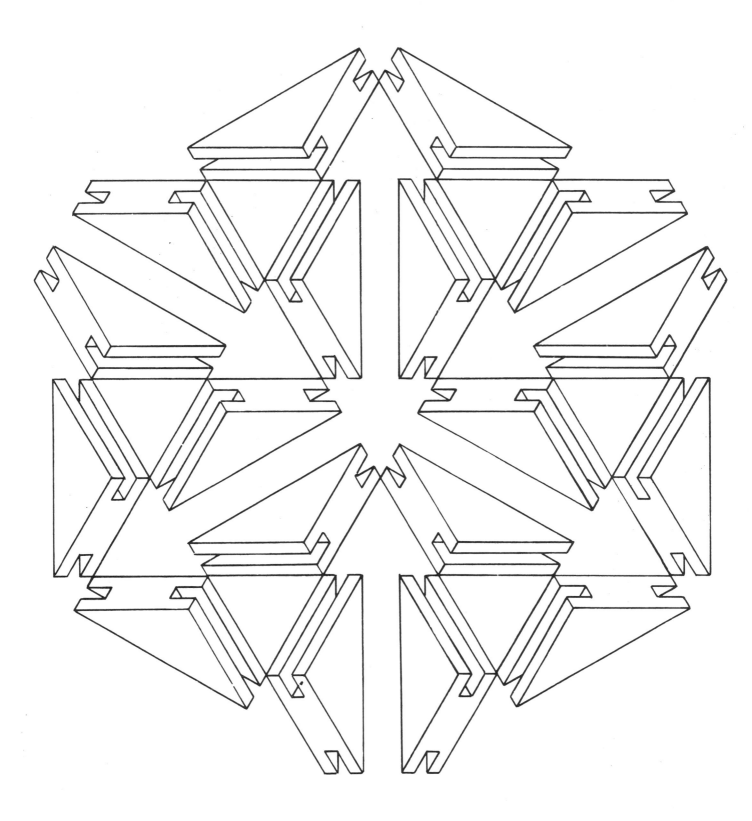

Plate 15

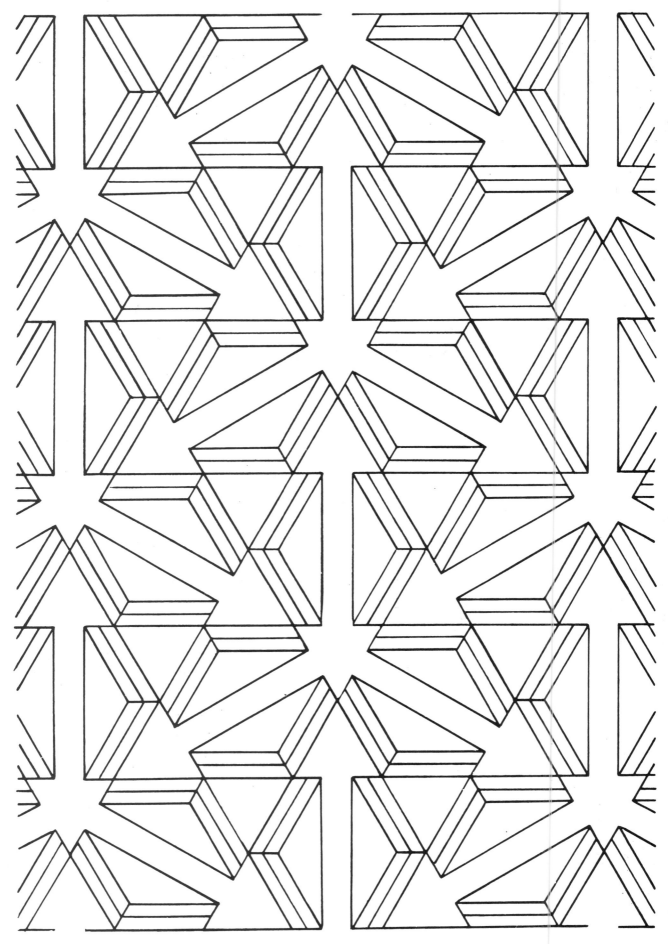

Plate 16

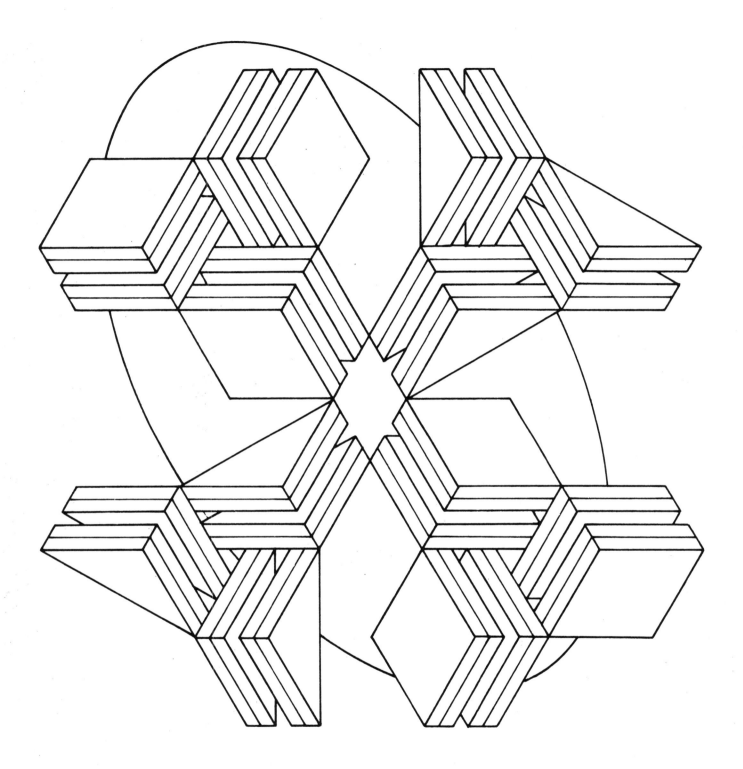

Plate 17

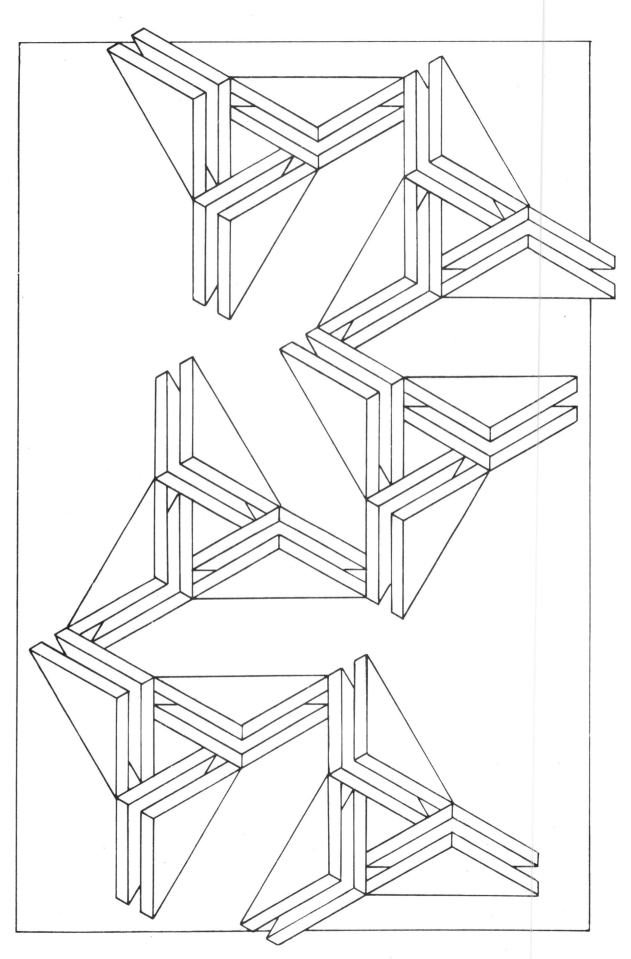

Plate 18

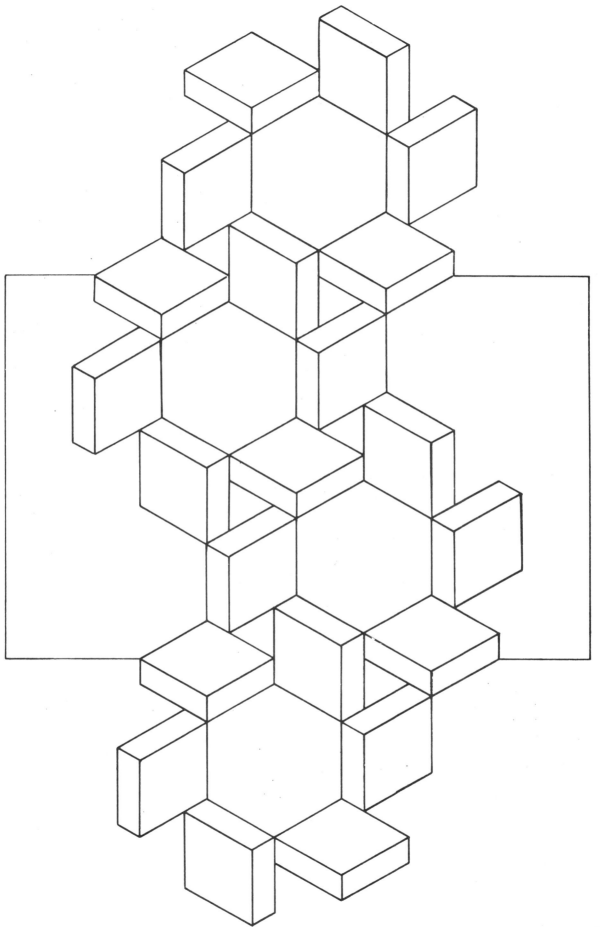

Plate 19

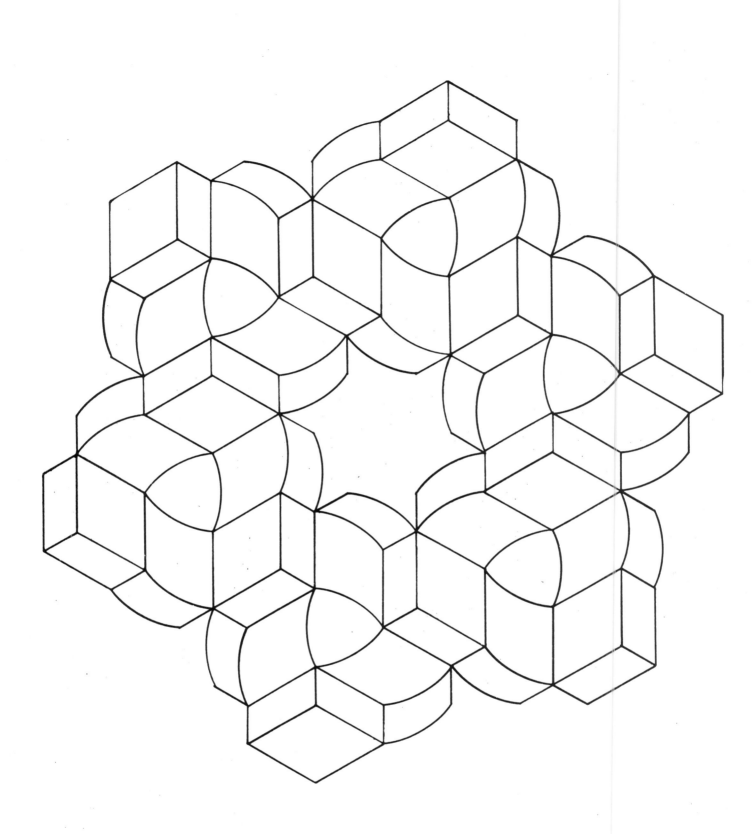

Plate 20

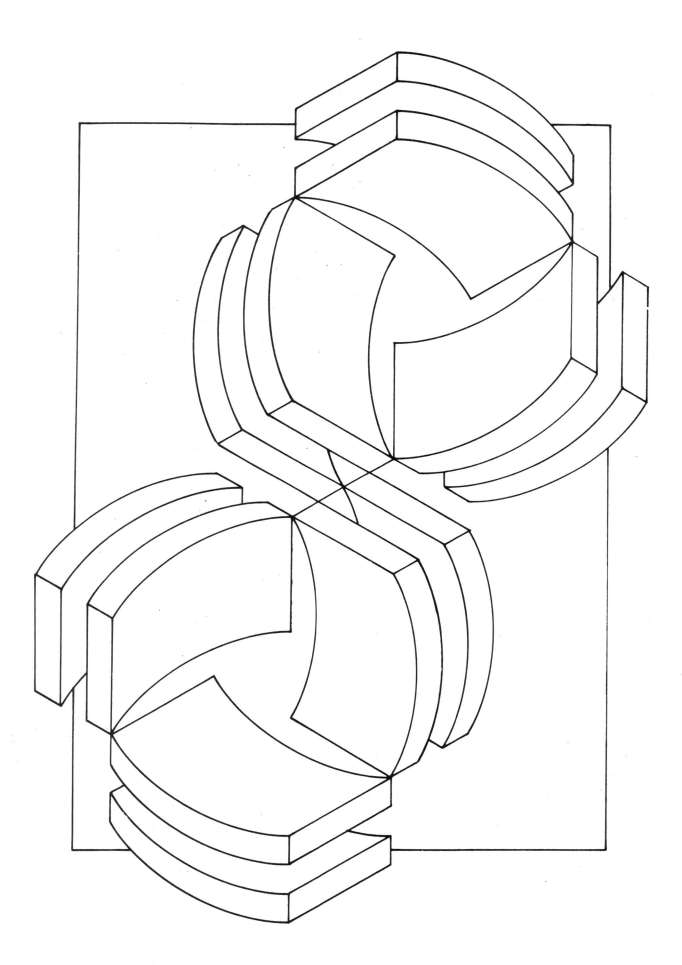

Plate 21

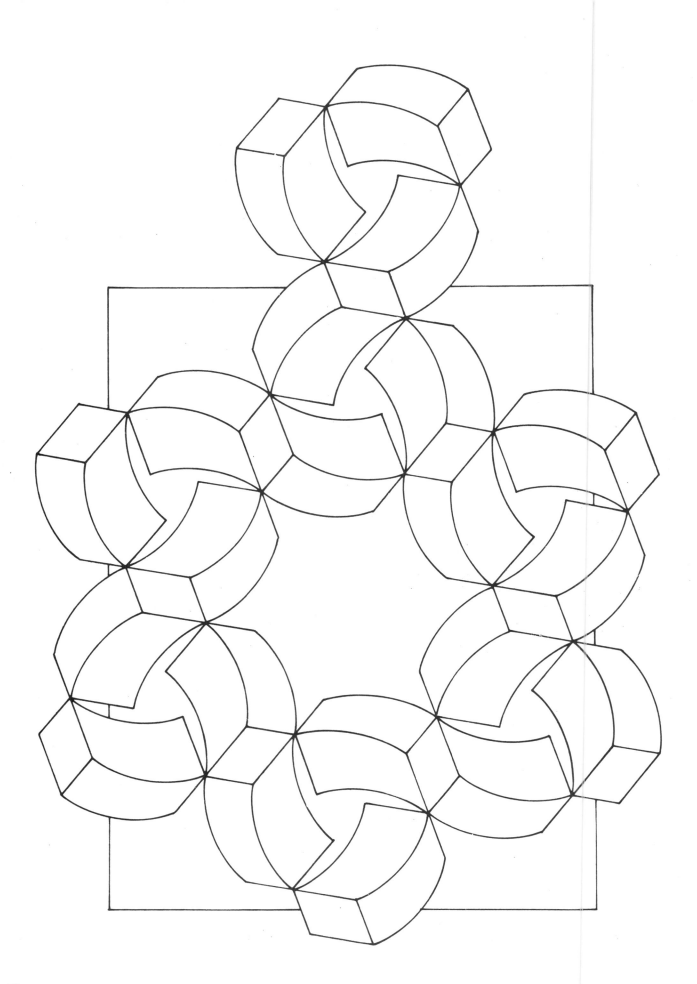

Plate 22

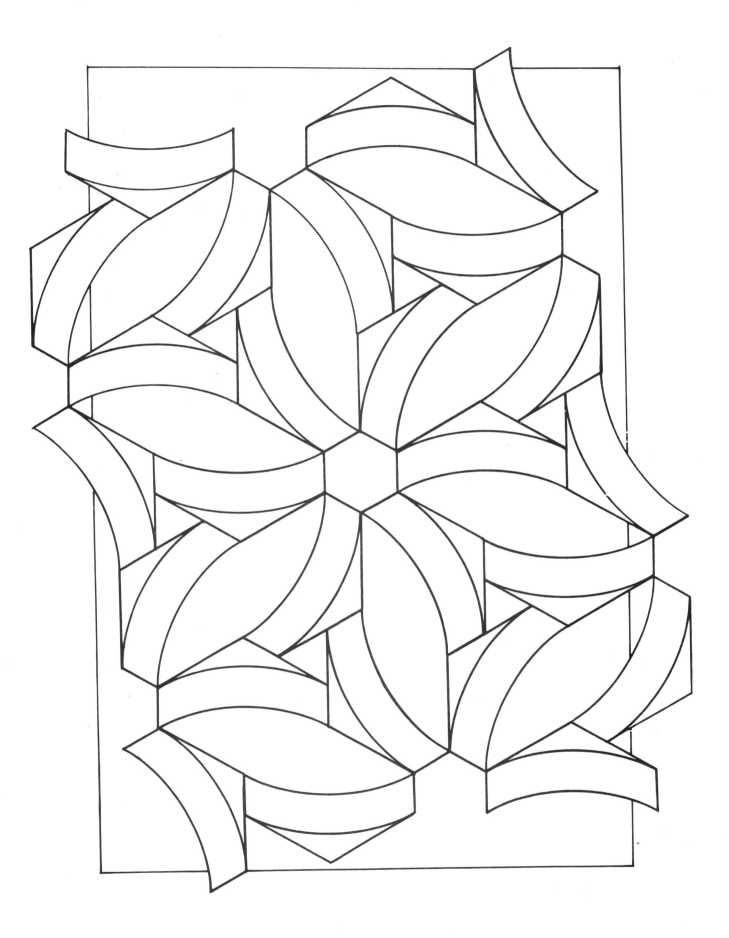

Plate 23

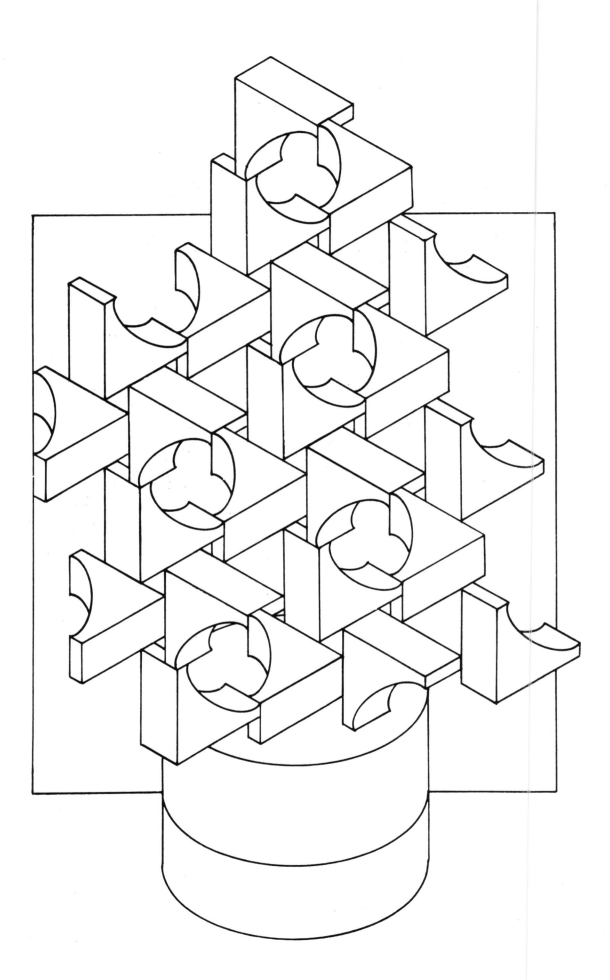

Plate 24

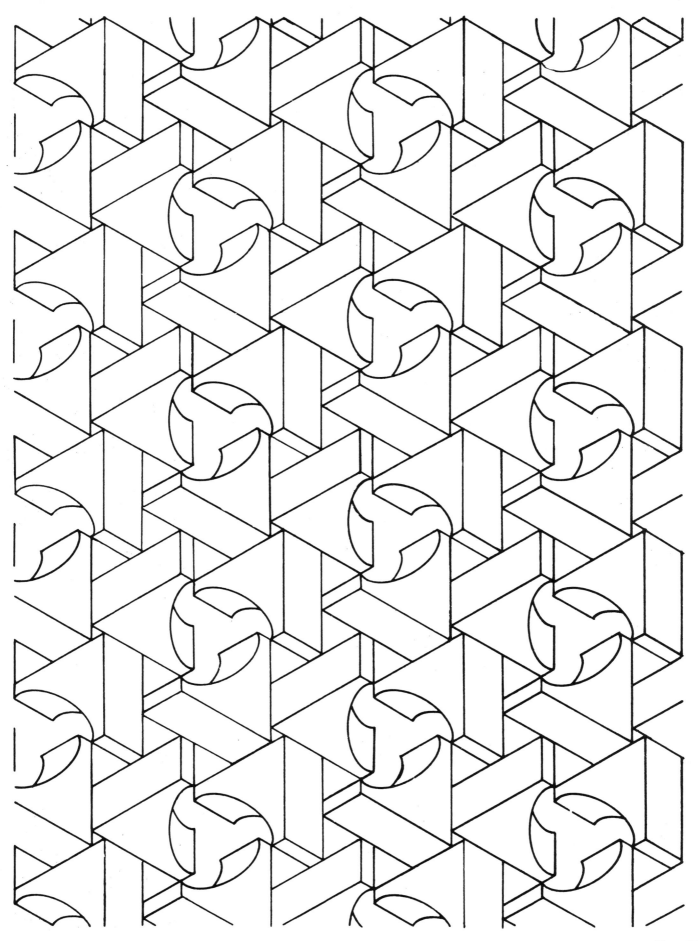

Plate 25

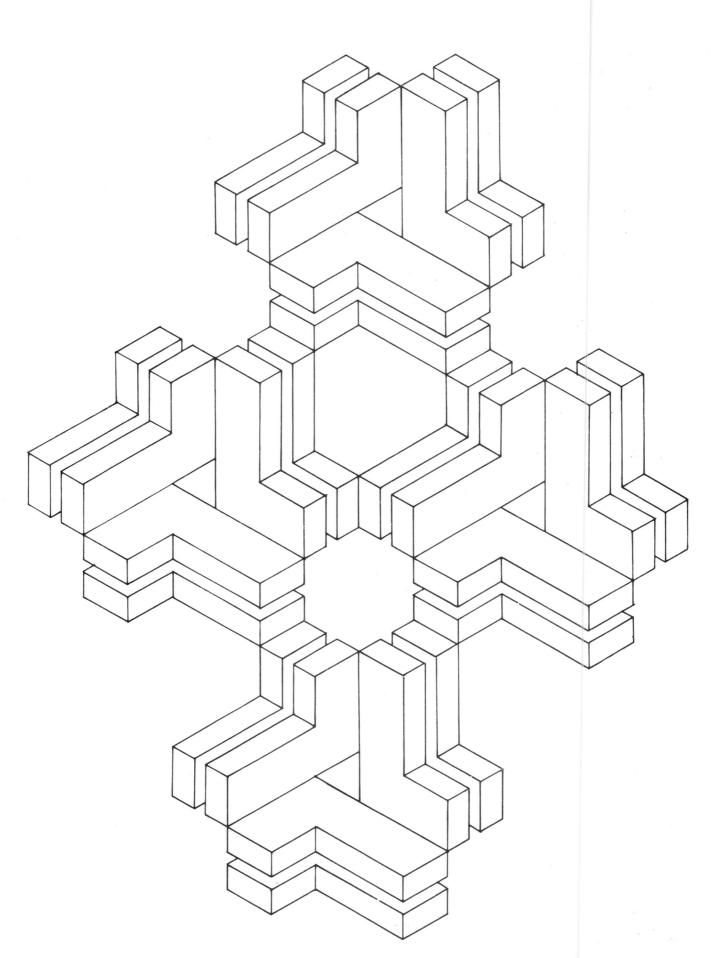

Plate 26

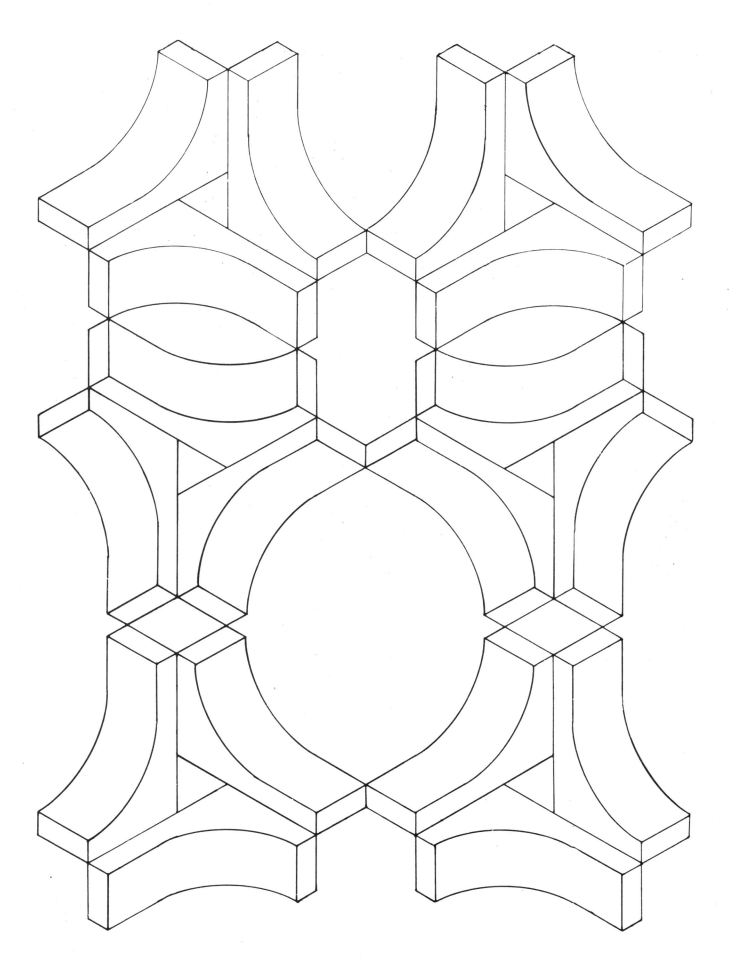

Plate 27

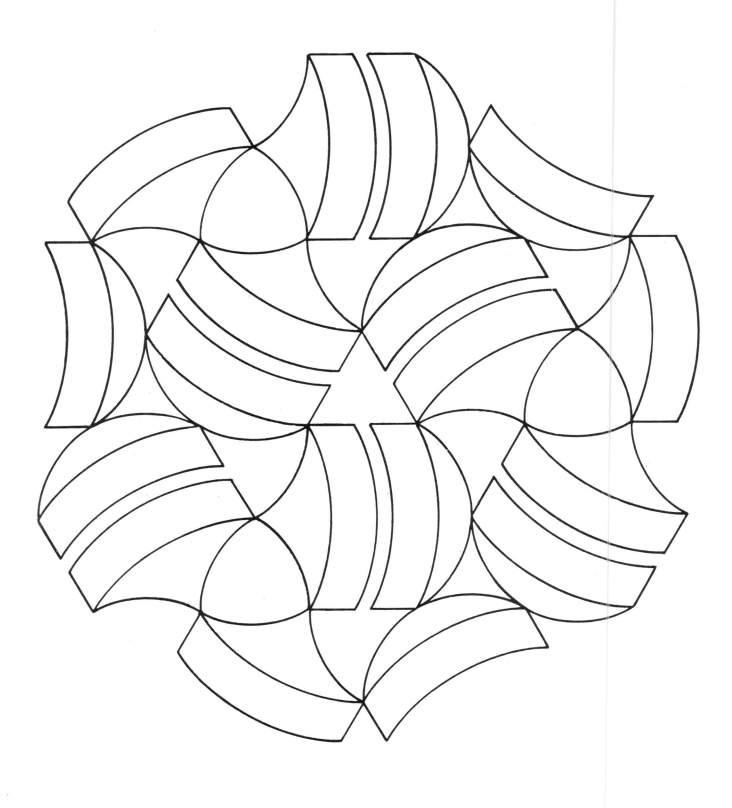

Plate 28

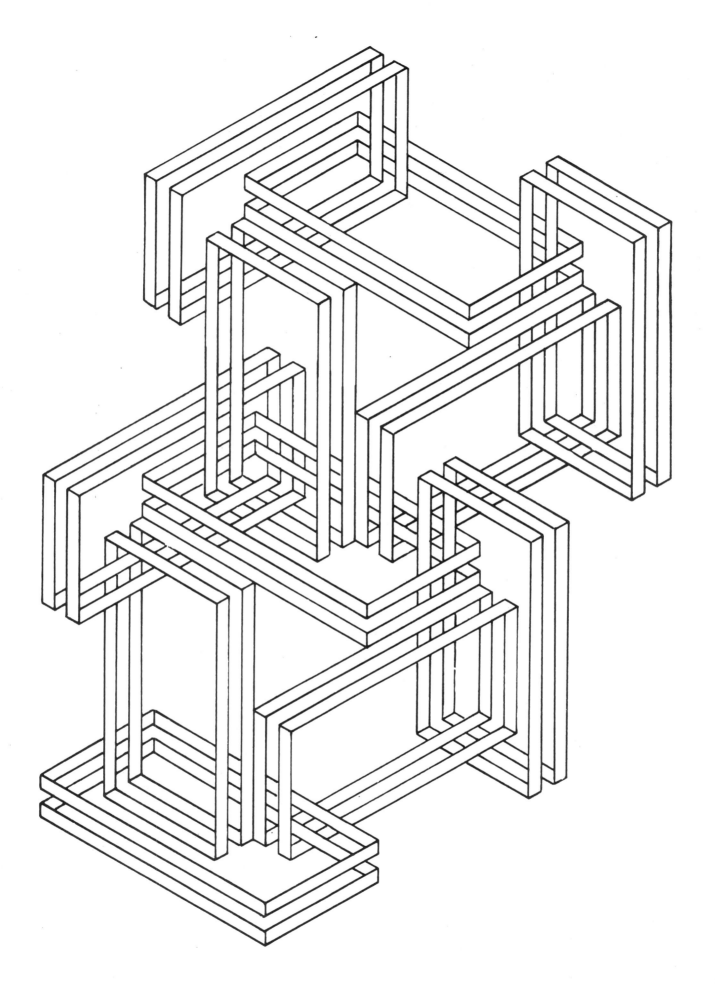

Plate 29

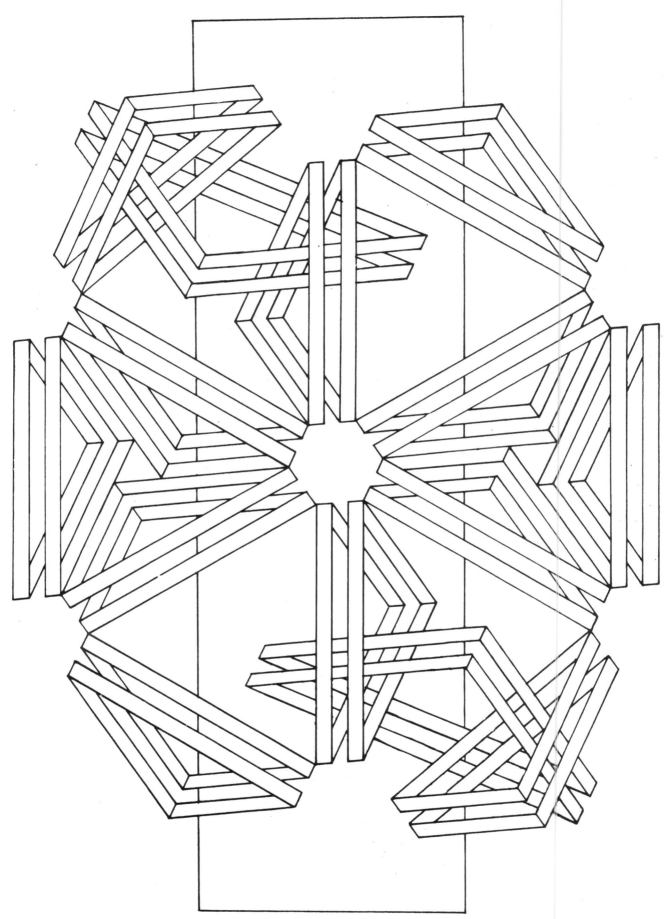

Plate 30

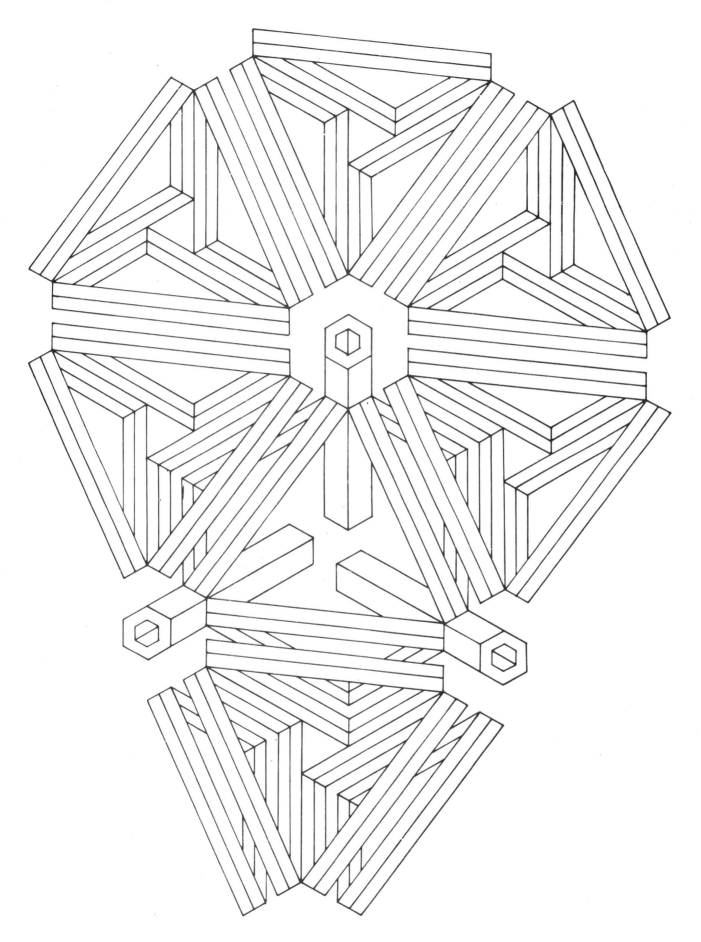

Plate 31

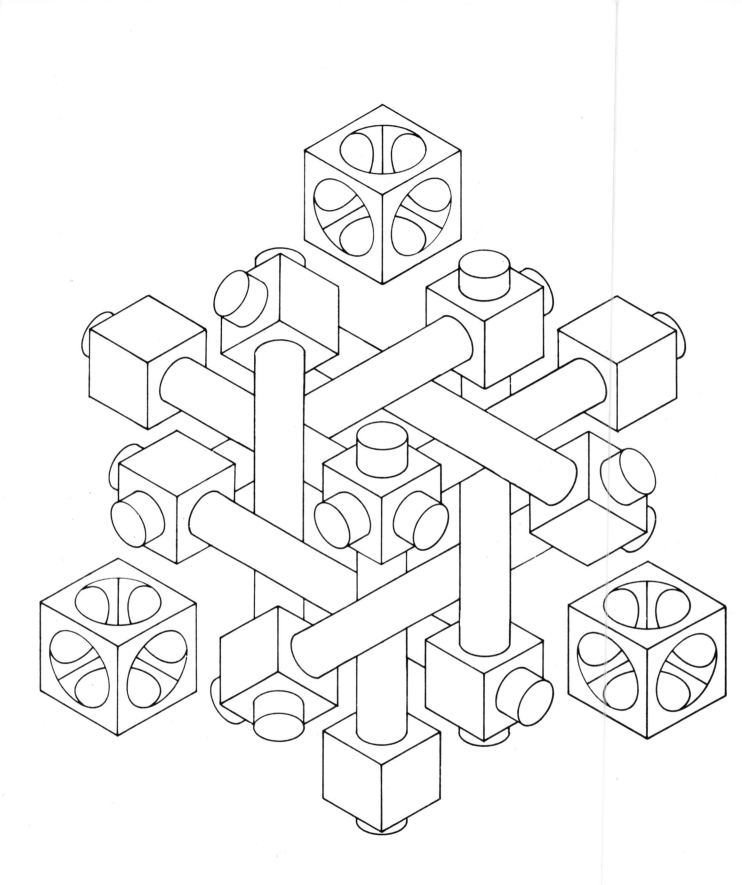

Plate 32

(The text continues from page 14.)

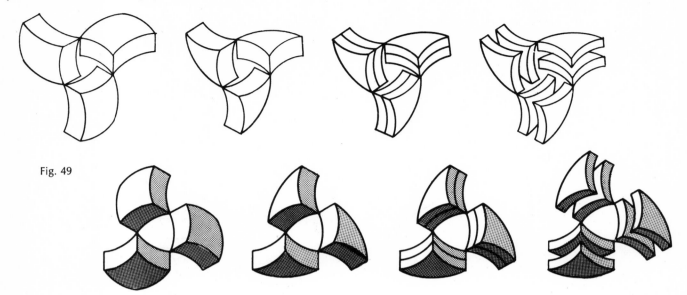

Fig. 49

Flexed triads again

The flying triad has new potential when made up of flexed blocks. In the examples of Figure 49, the blocks are curved in two dimensions, and then metamorphosed into triangular and split shapes. This is merely a hint of the possibilities. The floret design (50) is the result of grouping triads around a central hexagon. Once again, all the modules can be used to generate extended patterns; Figure 51 is a typical design.

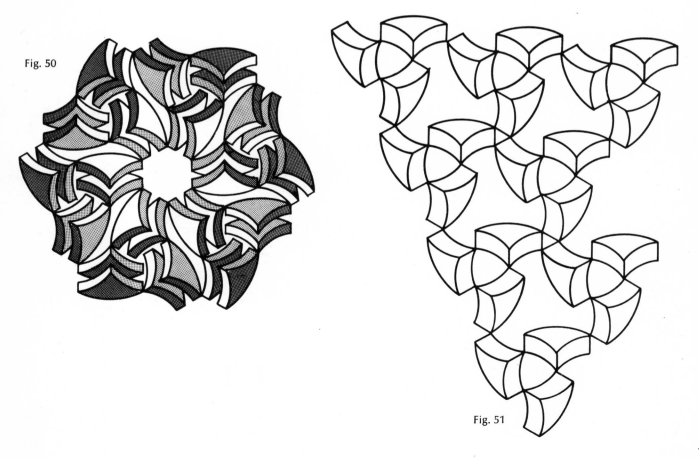

Fig. 50

Fig. 51

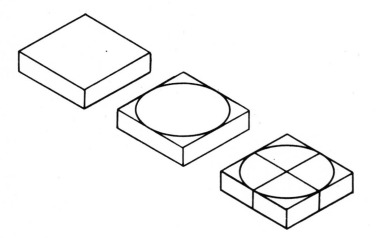

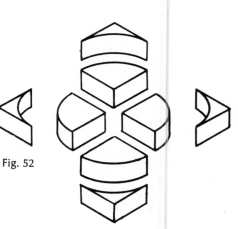

Fig. 52

Curvilinear constructions

Take an isometric square block and cut a circle out of it, of equal diameter to the side of the square. Then quarter the square and separate the bits (52). The original block is now divided into eight parts—for easy reference, let's call the center shapes "quadrants" and the corner pieces "arcs." Each of these pieces may be used to create triads, combined in the ways already described on these pages (53, 54).

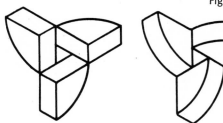

Fig. 53

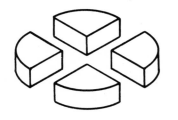

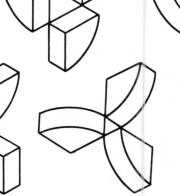

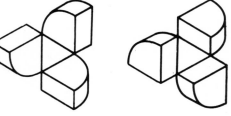

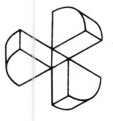

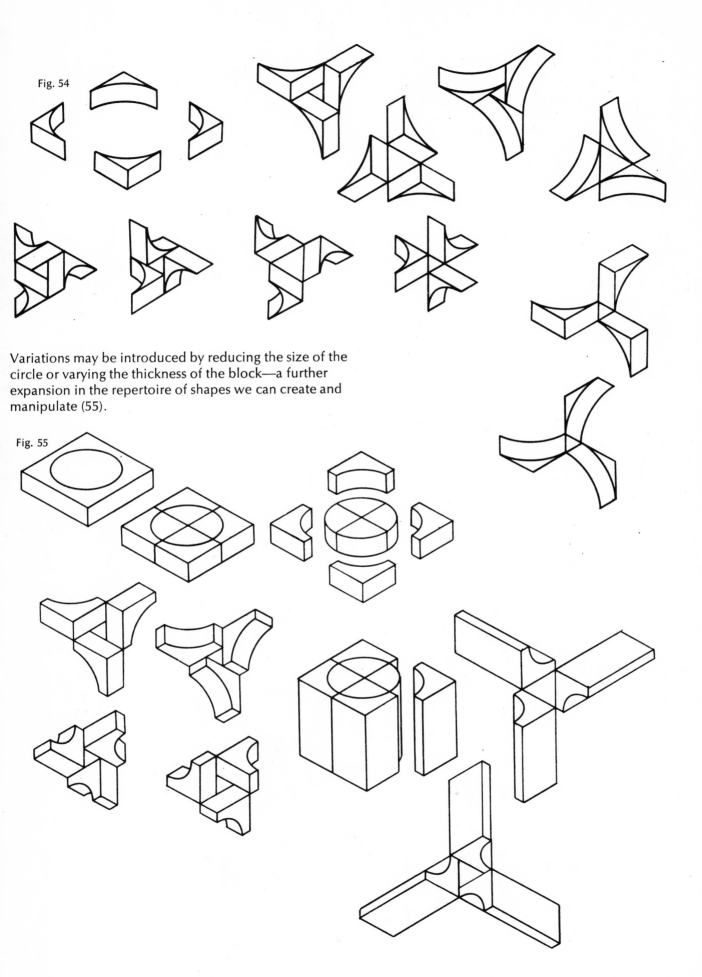

Fig. 54

Variations may be introduced by reducing the size of the circle or varying the thickness of the block—a further expansion in the repertoire of shapes we can create and manipulate (55).

Fig. 55

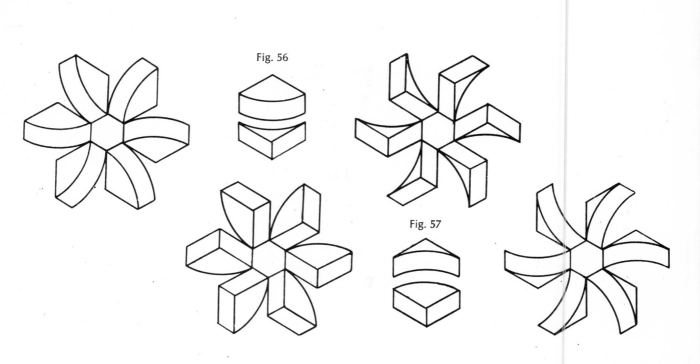

Fig. 56

Fig. 57

The designs on this page use quadrant and arc shapes grouped around hexagon centers, to create more whirligig figures (56, 57, 58).

The whirligigs are then extended so that we have groups of six triads around each hexagon, forming diverse floret designs (59–65). All these shapes may be used as unit blocks in the assembly of repeat patterns (66).

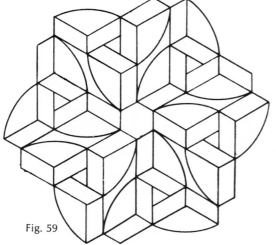

Fig. 59

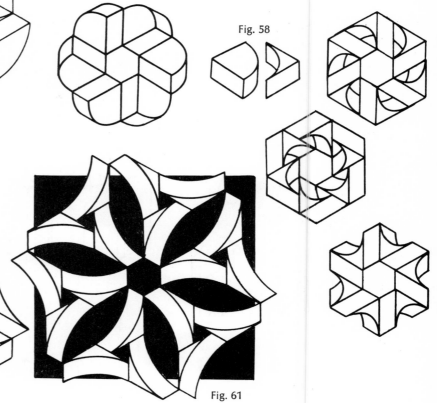

Fig. 58

Fig. 61

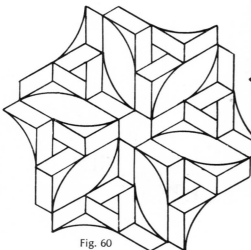

Fig. 60

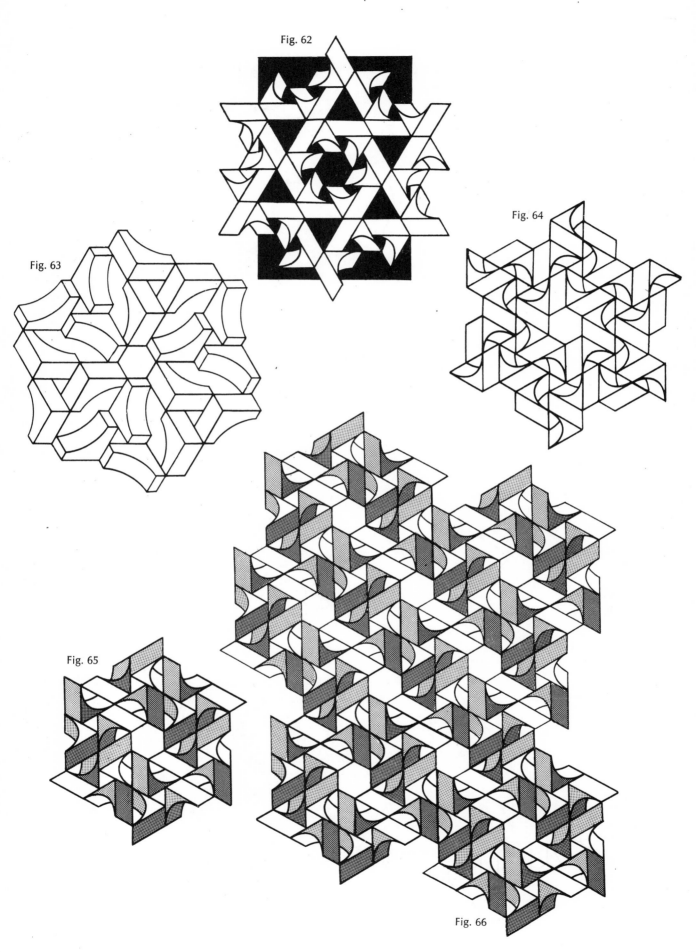

Fig. 62

Fig. 63

Fig. 64

Fig. 65

Fig. 66

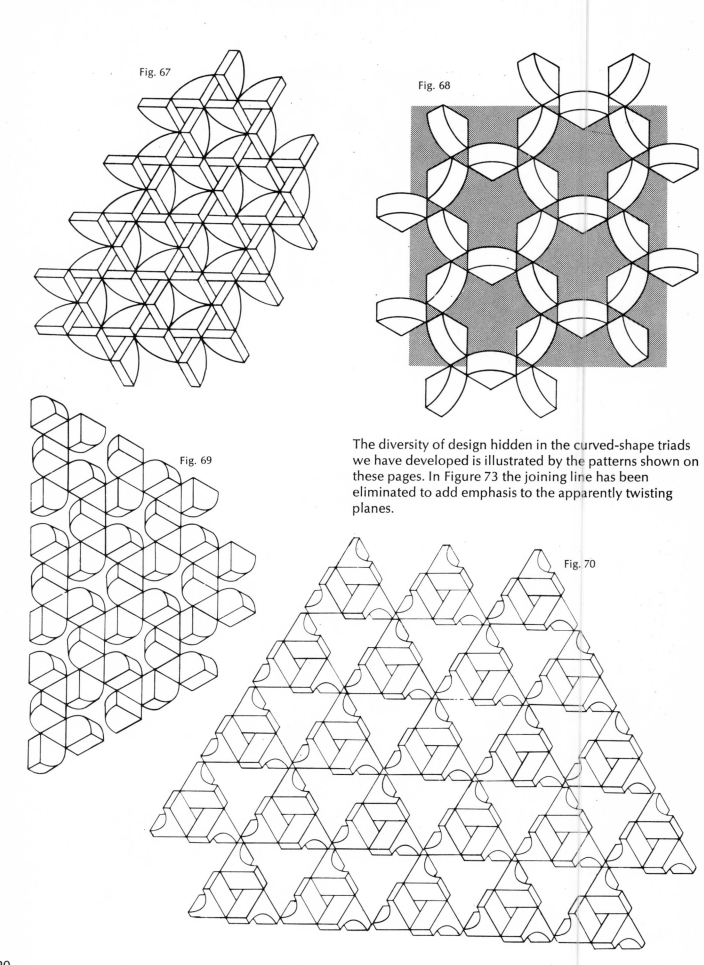

Fig. 67

Fig. 68

Fig. 69

The diversity of design hidden in the curved-shape triads we have developed is illustrated by the patterns shown on these pages. In Figure 73 the joining line has been eliminated to add emphasis to the apparently twisting planes.

Fig. 70

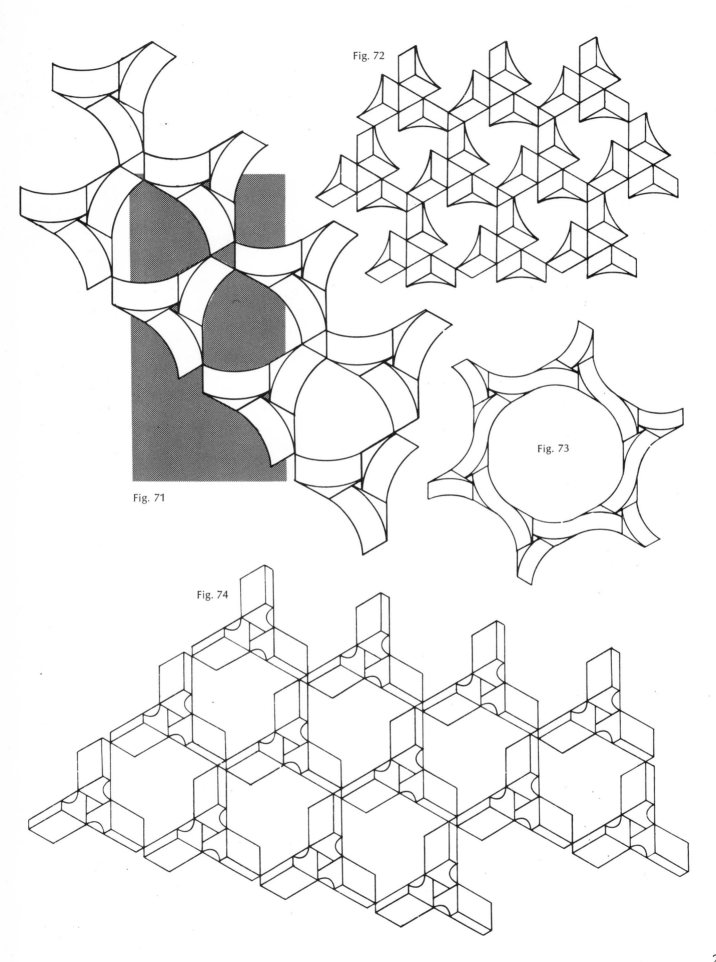

Fig. 72

Fig. 71

Fig. 73

Fig. 74

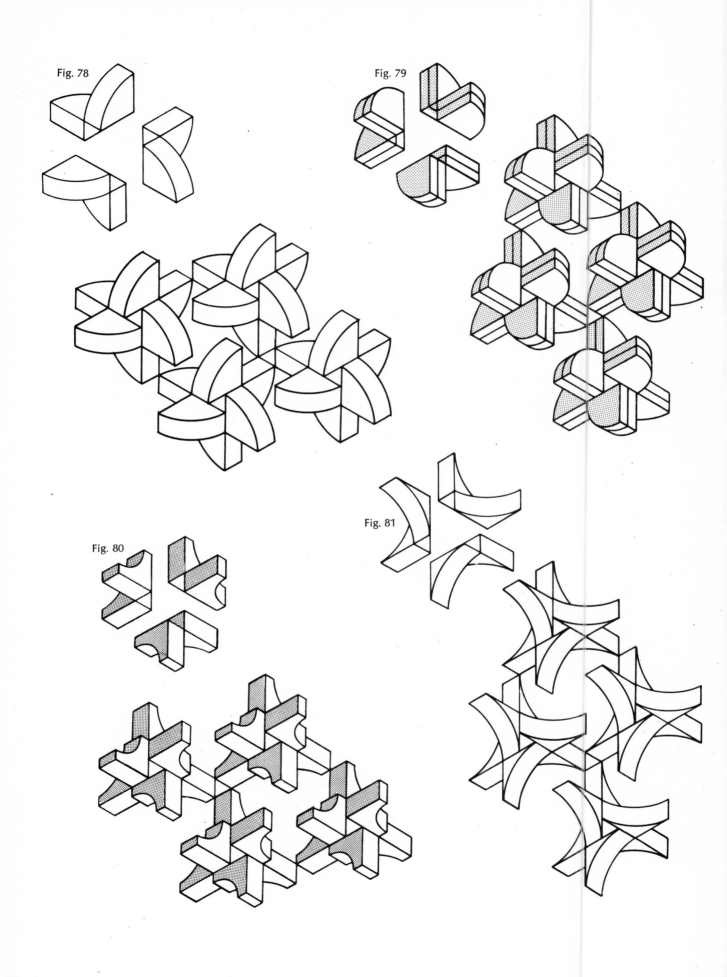

Fig. 78

Fig. 79

Fig. 80

Fig. 81

Complex triads

Triad modules can be made more complex. In effect, all we need to do is position two blocks at right angles, touching along one edge. Three of these units may then be brought together to make the triad (75). Four of these modules link to form the impressive mobile alongside (76). Extension by the addition of identical triads produces the pattern below, a complicated lattice that takes on surprising spatial depth once tone, or color, is added to the outline (77).

Fig. 75

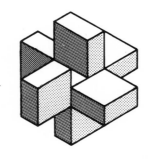

Fig. 76

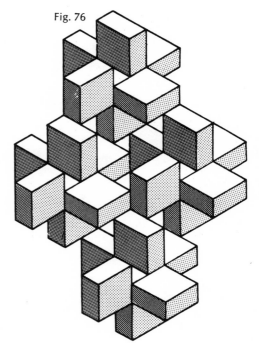

Other shapes may be combined in a similar manner. A few variations appear on the facing page. The sketches show the basic unit and indicate how it is "assembled" to form a complex triad which may then be linked with similar units (78–81).

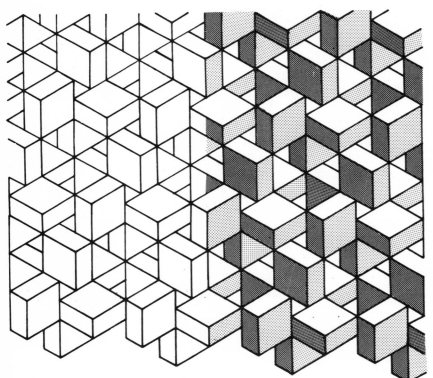

Fig. 77

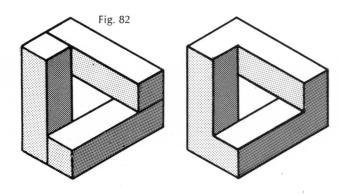
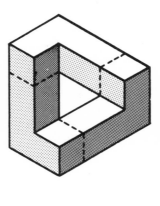
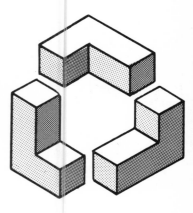

Fig. 82

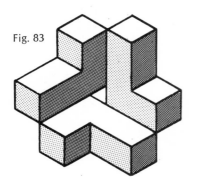

Fig. 83

Back to basics—again

Look at the basic triad again. Suppose the blocks were molded together as a single unit—we could then cut it into three L-shaped pieces (82). And we're promptly back in business again with yet another shape to play with. The pieces may be reassembled into another impossible object (83) or, alternatively, grouped around an irregular hexagon: this shape acts as a center link for L-shaped triads (84).

The other isometric view of this L-shaped triad (85), used in a split variation, is linked around the hexagon center in Figure 86.

Inevitably, these linked figures may be extended as all-over patterns.

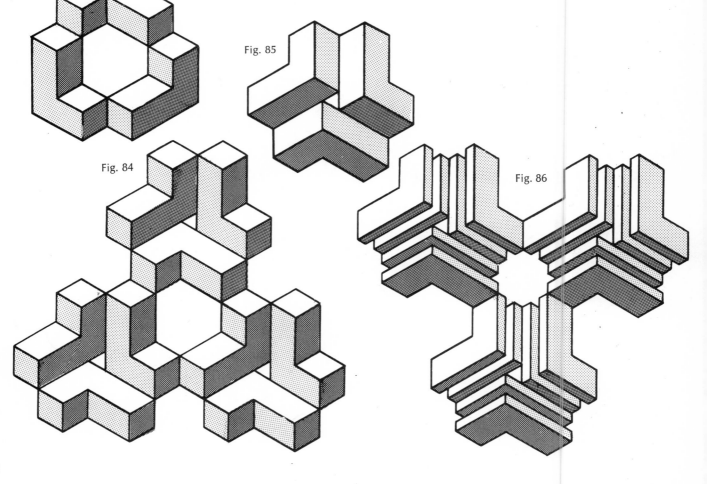

Fig. 84

Fig. 85

Fig. 86

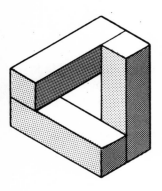

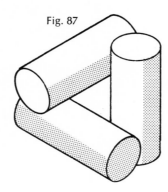
Fig. 87

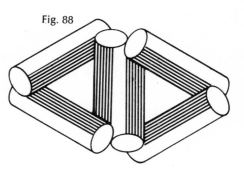
Fig. 88

Entanglements

Converting the rectangular blocks of a basic triad into
cylinders gives another impossible object (87). Combining
two of these cylindrical triads with a Thiery link results
in a puzzle-object (88).

Linking two shapes provides an interesting variation
(89). Is it an impossible object? I leave you to decide, but
this shape certainly provides interesting visual
complications when intertwined with a hexagon of linked
cylindrical triads (90). The result may be carried over
into a mind-bending all-over pattern—though it requires
a certain degree of concentration to keep everything going
in the direction intended!

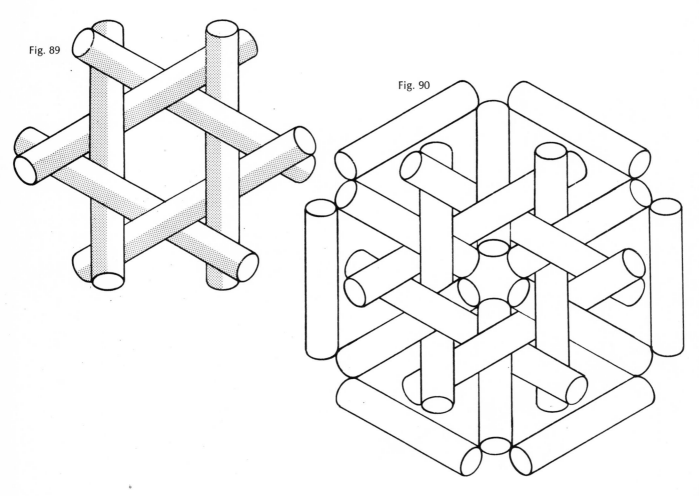
Fig. 89

Fig. 90

Some thoughts on color

Most books on the subject of color refer to the color
wheel. This is a device which, by devious logic, twists
the band of the visible spectrum around on itself and links
the two extremes of red and violet to form a basic color
guide. Since the spectrum is continuous and its colors merge
imperceptibly, arbitrary breaks are introduced into
the color wheel, separating distinctive colors into neat
manageable parcels. Views differ on how this should be
done; some authorities claim that at least 160 distinguish-
able hues can be seen in the spectrum, but usually twelve
divisions are made. These are the three primary colors,
red, blue and yellow; three secondary (complementary)
mixtures, orange, green and violet; and, conveniently,
six linking in-between colors. This arrangement is
adequate to highlight a few rule-of-thumb relationships
in a natural order of colors that follows the fixed
sequence of the spectrum. Planning a harmonious color
scheme from the wheel is simple—select a few adjacent
colors grouped around a dominant color. If we pick blue as
a starting point, for example, then it can be used with
blue-green, green, and yellow-green or, alternatively,
with blue-violet and violet. And such schemes may be
spiced with the contrast of a complementary color such as
orange, or red-orange.

But the color wheel has obvious shortcomings. Twiddling the
color control of a TV set demonstrates this. With the
control turned way up the color is intensified—luscious
saturated pure hues without tone. Turn it down gradually
and the color loses intensity until eventually the picture
is a gray tonal image on the screen, existing independently
of chromatic color.
The spectrum band represents only one dimension of color,
that of hue. But each hue moves through a second dimension
of intensity, as well as a third dimension of tone (91).
So sophisticated systems of color classification have been
devised, based on these three dimensions of color; it is
worth looking at the systems of Albert Munsell and Wilhelm
Ostwald. They offer valuable reference standards for the
designer and technologist wishing to specify or match
colors and to control quality. But it is a sobering
thought that even such complex systems do not offer real
solutions to the painter's problems of handling color . . .
Colors have their own built-in illusions—they often
fool us into seeing colors that do not, physically, exist.
Early in the last century Michel-Eugene Chevreul, in the
course of his work at the dye laboratories of the Gobelin
tapestry factory in France, discovered the effect of
simultaneous contrast of adjacent colors. His investigation
into complaints of dye defects revealed that optical effects
were to blame—after-images resulting from the
juxtaposition of certain colors—rather than any
shortcomings of the dyes. This finding led Chevreul to
make a more general inquiry into the effect. The results

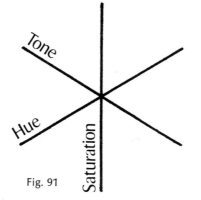

Fig. 91

of this research were published in 1839 and established
that all colors, even blacks and grays, interact when
placed together.
An example of this is shown in Figure 92, a band of grays
graded from light to dark in even steps. There is an illusory
"fluting" effect, since each interval, although a flat
gray, appears to be darker on the side nearer to the
light end, and lighter on the side nearer to the dark end.
This effect results from a dark gray inducing a lighter
gray to appear darker, and vice versa, with a perceptual
modeling of each flat tone. A similar effect happens
with a gradated monochrome color.

Fig. 92

The effect becomes very complex when several areas of
different colors touch, and a single color can be made
to vary in several different directions simultaneously.
Complementary hues like red and green intensify each other
when viewed together: if both colors are pure and highly
saturated, a disconcerting dazzle effect is produced
where they meet—an optic unsettler exploited by the
op artists.
Every color we see changes in relation to surrounding
colors, each one affecting and affected by the others,
and each change results in a chain reaction of contrasting
perceptual effects: a dynamic process of concern to all
thinking painters . . .
The shift to abstraction in the visual arts at the turn of
the century freed the artist from the need for pictorial
representation and the use of descriptive color. Among
the artists who wholeheartedly investigated color as
a pure sensation, perhaps the most outstanding is Josef
Albers. He developed and extended the findings of
Chevreul to create an area of painting based on perceptual
problems, anticipating the op-art movement that came in the sixties.
Albers emigrated to the States when the Bauhaus was closed
in the thirties, and continued teaching at Black Mountain
College in North Carolina, moving to Yale University in
1950. His book *Interaction of Color*, an invaluable series
of exercises and a guide to a personal exploration of the
world of color, is essential reading.

Albers shows you how to make the same color look different, and
how to make two colors look alike; deals with color
boundaries and the spatial organization of color; and
emphasizes that an extensive vocabulary of color is
acquired only through a widening of experience—education
is self-education.

It is often cheerily asserted that warm colors—reds and oranges—will appear to advance, to float about the picture surface, while cool colors—light blues, greens, steel grays—appear to retreat below it. It's a good rule of thumb, but you can't take such effects for granted. In many of his prints and paintings, the artist Victor Vasarely succeeds in inverting the expected results by subtle manipulation of tonal and color contrasts to push colors out of and into the picture plane in surprising ways. It's all a matter of the relative "temperature" of color, and in his book Albers demonstrates this with an analogy familiar to science students. If you dip your left hand into warm water and your right hand into cold, and then dip both hands straight into a bowl of lukewarm water, you experience conflicting sensations. The lukewarm water feels cold to your left hand and warm to your right hand. So it is with color sensations; within each hue we can experience such apparent contradictions as cool reds and warm blues.

Both sight and insight are needed in dealing with color because we are faced with perceptual reactions as well as physical facts. Think of the individual color preferences we develop, the dislikes we form, the wealth of associations we acquire; it should be obvious that color is a very subjective phenomenon.

Practicalities

The designs on the center pages are empty frames that you can manipulate with color. Some of them may seem deceptively simple until color brings out hidden intricacies; other apparently complex designs need the addition of logically placed color to help the eye appreciate an underlying simplicity of structure. Selective placing of color will enhance the feeling of solidity in designs where surfaces move above and below the picture plane: try the effect of using warm and cool colors. Where Thiery links introduce an indecisive positioning, paint the panels in spatially ambiguous colors—yellow, yellow-green, violet. You'll find that darker colors tend to stand out more than lighter colors on a white background, and that a dark background makes colors seem more brilliant. Look at the work of many contemporary painters and you will see that harmony is not restricted to a small section of the color wheel; these artists revel in the richness of saturated hues. There's no infallible rule that colors must be subordinated to a dominant hue. Other artists avoid these "hostile attacks on the senses" (a phrase of Albers) and work in subdued, closely related colors. Both approaches are equally valid.
The black outlines of the designs are there as a guide; if you wish to eliminate them so that colors may interact fully, it is best either to work with an opaque paint such as gouache or to use cut paper.
You can, of course, complete the designs just by using tone. Since they are available as pigments, artists tend to

regard black, white and the intermediate grays as colors—achromatic and non-spectral colors. You can create tonal effects with pencil, ink or paint. It is also possible to suggest tone by the use of fine regular dots or parallel lines, which at a certain distance from the eye fuse to give the impression of a flat gray tone. Such mechanical tints are available as adhesive-backed film sheets. Many of the illustrations on the text pages were prepared in this way.

Should you wish to redraw a design, perhaps to experiment with different color combinations, the only basic drawing equipment you need is a rule and a 30°/60° triangle. An isometric ellipse template is useful when drawing curved shapes.

And if you are tempted to make your own explorations into the world of the triad, to pursue changing shapes and create your own designs, then you will find it useful to plan your work on a pad of isometric graph paper, especially when developing an extended pattern. The regular grid helps you avoid any deviations that may result from inaccuracies in layout. If you find the use of drawing instruments irksome, the graph paper will enable you to sketch freely and accurately while working out your ideas. The designs on these pages by no means exhaust the possibilities of that simple shape with which we started out . . . the triad.

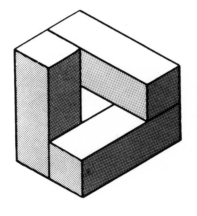

Recommended reading

M. Luckiesh, *Visual Illusions* (Dover Publications, 1965). A basic text on illusions and their causes.

Richard L. Gregory, *Eye and Brain: The Psychology of Seeing* (McGraw-Hill Book Company, 1973). A lucid account of the science of vision, with material on illusions that takes up where Luckiesh's book leaves off.

Rudolf Arnheim, *Art and Visual Perception: A Psychology of the Creative Eye* (University of California Press, 1971). The artist's point of view.

William C. Seitz, *The Responsive Eye* (Museum of Modern Art, 1965). A useful introduction to the art and artists of perceptual abstraction: the catalog of a key exhibition of the mid-sixties.

J. L. Locher, ed., *The World of M. C. Escher* (Harry N. Abrams, 1972); Werner Spies, ed., *Josef Albers* (Harry N. Abrams, 1971) and *Victor Vasarely* (Harry N. Abrams, 1970). The work of three artists with a delight in illusion.

Josef Albers, *Interaction of Color* (Yale University Press, 1971). An invaluable guide to the discovery of color and its subtleties, by a pioneer of perceptual painting.